IMAGES
of America

THE TWENTY MULE
TEAM OF
DEATH VALLEY

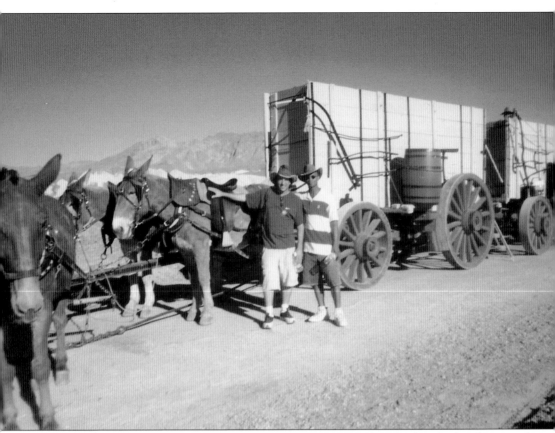

The author and his son Shon are seen here with Clyde, one of the wheelers (mules closest to the wagons). The team appeared at the 1999 annual Death Valley '49er Encampment. It was the first time the team had been in Death Valley in nearly 50 years.

ON THE COVER: The Twenty Mule Team became a television star beginning in 1952, when the western series *Death Valley Days* went on the air. The team was filmed for the opening sequence of the show.

IMAGES
of America

THE TWENTY MULE
TEAM OF
DEATH VALLEY

Ted Faye

ARCADIA
PUBLISHING

Published by Arcadia Publishing
Charleston, South Carolina

Printed in the United States of America

Library of Congress Control Number: 2012931888

For all general information, please contact Arcadia Publishing:
Telephone 843-853-2070
Fax 843-853-0044
E-mail sales@arcadiapublishing.com
For customer service and orders:
Toll-Free 1-888-313-2665

Visit us on the Internet at www.arcadiapublishing.com

To all of my Death Valley friends, past and present. And, of course, to Mom; and to Dad, who would have loved this little book.

CONTENTS

ACKNOWLEDGMENTS

Since I began my journey with the Twenty Mule Team more than two decades ago, it would be hard to thank all of the people who helped me write this book. At Death Valley National Park, it was the late Shirley Harding who started me on my Death Valley adventure. Her assistant Blair Davenport, who has now moved up the ranks, has been a supportive friend through the years. Greg Cox assisted with the Borax archives, now at the park. The folks I knew when Rio Tinto Minerals was US Borax include Ian White-Thomson, Maureen Lennon, Tana Burrows, and Susan Keefe, all of whom share a special interest in the mule-team history. Thanks to Rio Tinto Minerals for providing its corporate "blessing."

I want to acknowledge David Blacker and the Death Valley Natural History Association, Death Valley's concessionaires Xanterra and the Death Valley Lodging Company, and also the Death Valley '49ers; my friends at Death Valley Junction, Marta Beckett, Rich Regnell, and Mary Lee Chavez as well as photographer Merilee Mitchell; Susan Sorrells of Shoshone Development; Joyce Yount Dangermond, whose great-uncle Sam Yount worked with the original twenty-mule teams. Also, Betty Peters, who now runs the Borax Alumni Association, helped make at least one filming of a team possible. Thanks to my writer friends, Stanley Paher and Richard Lingenfelter, who have contributed thorough research and knowledge over the years. Thanks also to Robert Palazzo and Phil Serpico, who have shared their time and collections; the talented late Ken Graydon, who wrote the wonderful song "Mojave," and his wife, Phee; Eva LaRue and Angela Haag at the Central Nevada Historical Society; Lee Brumbaugh at the Nevada Historical Society; the University of Nevada, Reno Special Collections; Barbara Pratt of the Twenty Mule Team Museum in Boron, California; the Bancroft Library; John Cahoon of the Los Angeles County Natural History Museum, Seaver Center; and Jenny Watts, Erin Chase, and Anita Weaver at the Huntington Library.

Thanks to the production team of Allan R. Smith, Zatella Beatty, Steve Perry, Travis Brown, and my enthusiastic nephew Jamie Hall. And to John Fox, a gifted writer and producer, who has witnessed the evolution of this Death Valley journey from the beginning. I also thank Brian and Bonnie Brown of China Ranch Date Farm, Henry Golas of the Death Valley Conservancy, and Preston Chiaro of Rio Tinto, also with the conservancy. Through the years, their encouragement and help has allowed me to research and document this fascinating story. Special thanks to Bobby Tanner: it is a rare privilege to work with someone who has, through knowledge of the mule and careful attention to the slightest detail, resurrected the art of driving the 20-mule team.

The photographs throughout this book come from a variety of collections and sources. Unless otherwise noted, they have been provided by the Borax archives at Death Valley National Park.

INTRODUCTION

One day in 1892, on a dry lake bed called Coyote Lake near the railroad town of Barstow, California, photographer Frederick Monsen staged a reenactment scene. With the help of Pacific Coast Borax Company, a team of 18 mules, two horses, two large freight wagons, and a water wagon were hitched together and driven across the playa. Two men were in the photograph: the driver, or teamster, sitting on the horse closest to the wagon, and his assistant, or swamper, in the front wagon. Monsen had his own small wagon with equipment and drove it away to set his camera in place. As the wagons began to move, Monsen took several photographs. One of them was chosen by the company's marketing team of Joseph Mather, his son Stephen, and the company president Frank Smith. For the next 50 years, the image was used for the promotion and packaging of the newly named laundry product: 20 Mule Team Borax.

The photograph read, "Twenty Mule Team Hauling Borax Out of Death Valley." Never mind that the photograph was taken more than 100 miles from the famed valley or that borax mining had ceased there more than four years earlier. It clearly was not important that the staging of the image was unusual, since the swamper (assistant/brakeman) more commonly would be working the brakes in the rear wagon, not standing in the front. Nor did it seem to matter that the animals closest to the wagons were horses not mules, in this "20 mule" team, although that too would later become part of the story. And, of course, there were the deep tracks in the center of the photograph where the wagons had turned around for another "take," but no one seemed to care. This was the Twenty Mule Team at work (or at least looking like it was working), and it would sell borax by connecting the product to Death Valley and, in turn, to the Wild West.

By 1892, Americans were feeling nostalgic about the old West. Both native peoples and the land had been subdued. There was a sense that the country was losing something. After all, as historian Frederick Jackson Turner would later write, "This expansion westward with its new opportunities, its continuous touch with the simplicity of primitive society, furnish the forces dominating American character." The belief in the Wild West, its untamed land and wide-open spaces, filled Americans with hope, belief in themselves, and the possibility of endless opportunities. Dime novels, news of western expeditions, and even Buffalo Bill's Wild West show continued to fuel the wistful look back to the "good old days." It was the perfect time to capitalize on the nation's mood.

Teamsters (as they were called for driving teams of animals), large wagons, strings of mules—all set in a wide-open, expansive desert setting—provided the perfect image for connecting borax soap to the nostalgia for the old West. The image was powerful, and the company knew it. For the next 50 years, it was used on everything from the soap product itself to jigsaw puzzles, children's books, playing cards, cutouts, cartoons, and in songs. Starting in 1930, the sound of wagons and mules opened a weekly radio show called *Death Valley Days*, and later, in 1952, the program went to television. Beginning in 1954, a plastic scale model of the team could be purchased by sending in a box top from 20 Mule Team Borax and $1. Every day, when Americans went to their pantry

and used their box of Twenty Mule Team product, saw ads in the paper, heard it on radio or saw it on television, they were connected to the old Wild West. In 1892, Joseph Mather, his son Stephen, and Frank Smith must have known what they were doing. For out on that desert playa, they created an icon that reinforced the image Americans had of themselves: tough, tenacious, hard working, optimistic, and forward moving. The image itself shows a dynamic forward motion, including the mules, the driver, and even the misplaced swamper.

That image of driving forward in the wilderness could not have come at a better time. The following year, 1893, the Columbian Exposition came to Chicago. It was a world's fair that would take America into the new century. It should have opened in 1892 to celebrate the 400th anniversary of Columbus's landing in the New World, but construction did not finished until 1893. When Pres. Grover Cleveland opened the event by pulling the lever on a dynamo that electrified the fairgrounds, the country was mesmerized. The world's first elevated electric railway was introduced, as well as the first Ferris wheel, and more than 27 million people poured in to see it all. Along the path of the elevated railway, riders saw something unusual: large ads for 20 Mule Team Borax featuring the photograph taken a year earlier on the dry lake bed. Amidst all of the progress celebrated at the fair, the 20 Mule Team advertisement had a special meaning.

It was even more poignant as it was during the exposition that a meeting of the American Historical Association was held. It was there that Frederick Jackson Turner made his declaration that the Western frontier was officially closed—that the railroads and settlements had effectively tamed the Wild West. Yet, near the entrance to the exposition, Buffalo Bill kept the West alive with a simultaneous appearance of his Wild West show, featuring Indians, cowboys, stagecoaches, holdups, trick riders, and ropers. The American West of the imagination took its place alongside the modern, forward-looking America featured at the fair. For Pacific Coast Borax, it could not have been a better match.

It was also fortunate for the company that at the same time Death Valley itself was gaining more notoriety. Stephen Mather had commissioned John Randolph Spears of the *New York Sun* to write a series of articles on Death Valley and the borax operations in December of 1891. The effort paid off when Rand McNally published the articles the following year, making it the first book on the Death Valley region documenting the mule teams and their historical connection to the valley. Gold-rush pioneers also began writing down their memories of their 1849 trek through what one immigrant called "the jaws of hell." William Lewis Manly published his classic *Death Valley in '49* in 1894; the Brier family told their horrific story to several publications. Other Death Valley '49ers were sought out to give their account of how they found and named this "valley of death." Newspapers such as the *New York World* touted Death Valley as "the pit of horrors, the haunt of all that is grim and ghoulish." The reputation of Death Valley continued to grow as a hell on earth. The borax company could not have been happier. The more dangerous and evil and wild and horrific Death Valley seemed, the more heroic, rugged, tough, and truly American those men, mules, and wagons looked in that God-awful place.

But what about borax itself? It is described in *The Grocer's Companion Handbook* of 1883: "The important practical uses to which borax is put are almost innumerable. It is used in soldering, it is used as a substitute for, and in the manufacture of soap; it replaces washing soda in the kitchen; is used as a preservative, is destructive to moths, ants, cockroaches and other vermin."

During the Industrial Revolution of the mid-1800s, borax was vitally important in the production of ceramic glazes and porcelain and in the manufacture of glass. During that time, most of it was imported to the United States from Italy and Tibet. It was not until 1856 at Clear Lake in Lake County, California, that Dr. John A. Veatch discovered the first borax in North America. Veatch came west for the gold rush and was one of the few who made a "snug sum of gold," buying a house in San Francisco then sending for his family. With his discovery, he now set his sights on developing a domestic source of borax that could be a "gold mine" of its own; however, the project would have to wait until the Civil War subsided. In 1864, as the war was ending, America's first borax company was formed, the Borax Company of California.

Even as Veatch was setting up his business, others were searching. In 1860, Veatch had also tested the waters of Mono Lake in Mono County, California, near the Nevada border—he found borax. He told William Troup, a prospector from Virginia City, Nevada, about his find. Troup began looking and 11 years later, in 1871, discovered borax on the salt-laden, dry lake beds at Columbus Marsh (near present-day Tonopah, Nevada) and Salt Wells (near present-day Fallon, Nevada). It did not take long for word to spread, and soon Columbus and Salt Wells were swarming with hopefuls staking borax claims.

It is into this borax frenzy that Francis (Frank) Marion Smith made his entrance. He came from Wisconsin and since 1867 had been roaming the West, moving from one odd job to another. Eventually, he became a woodchopper for the borax mining companies at Columbus Marsh. In 1905, in a speech to the sales team of the Pacific Coast Borax Company, he reminisced about the small cabin on Miller Mountain and the day of discovery in 1872, "As I tramped over the hills locating the timber I could distinctly see the gleaming white surface of Teels Marsh and one day I decided to make a tour of investigation. I took two woodchoppers with me and it did not take long to find that the marsh was covered with . . . borax, and, as it afterwards proved, I had chanced upon the very richest section of the deposits."

By 1874, Frank had gone into business with his brother Julius and established Smith Brothers Borax. They had managed to buy out anyone else who tried to compete with them at Teels Marsh. Their primary funding came from a $10,000 loan in gold from established businessman William Tell Coleman. Coleman came for the California Gold Rush of 1849. He found no gold but made a fortune selling apple pies (baked from his aunt's recipe) to miners for $10 each and eventually set up a store in Placerville. In time, Coleman developed a distribution business with offices in New York, Chicago, and San Francisco and a fleet of clipper ships delivering goods like fish and fruits from coast to coast—and later borax. Smith found in Coleman the business advantage he needed: distribution of his borax to the widest-possible market. Smith began buying up borax companies that were failing, like Emile Stevenot's Pacific Borax Company. He established another operation at Fish Lake Valley, and Frank was fast becoming known as "Borax" Smith.

Smith had little competition in the Nevada borax fields, but John and Dennis Searles provided a worthy rivalry in California's Mojave Desert. Having found some small traces of borax on a dry lake bed west of Death Valley in 1864, the two brothers went into full operation after hearing about all of the activity in Nevada. They set up an operation in 1874 and retained a distributor named W.L. Babcock from San Francisco. Yet whether it was the dry lake beds of Nevada or California, there was one problem that plagued these sites: transportation.

To get the product from the remote borax fields to the railroad and then on to San Francisco for refining and packaging required what were known as "long-line teams" or "big teams": strings of horses or mules hitched in pairs to sets of wagons hitched in tandem. The size of a team was determined by the weight of the loaded wagons. Depending on the weight, teams of 14, 16, 18, 20, 22, or 24 mules or horses were hitched to pull the wagons. For the Nevada borax operations, the nearest railhead was at Wadsworth, and the road to get there, according to a June 28, 1877, edition of the *Mining and Scientific Press*, was a distance of 150 miles "over a very sandy and desert country, with a great scarcity of water and feed for stock. Water has to be hauled from station to station, one drive alone being 40 miles over heavy sand. Across this desert water must be hauled, and a 14-mule team will consume 3,000 pounds of water while crossing." The same year, the *Scientific American* reported that the Smith Brothers "shipped their product in a 30-ton load using two large wagons with a third wagon for food and water drawn by a 24-mule team for 160 miles . . . to Wadsworth, Nevada . . . [to the] Central Pacific Railroad." So prevalent were long-line teams throughout the Nevada desert that the Studebaker Corporation of South Bend, Indiana, was producing the Nevada Iron Axle Wagon, capable of hauling 10 tons. And all of this was long before any wagons or mules were hauling in Death Valley.

On May 31, 1873, the *Scientific American* reported, "Extensive [borax] deposits have been found . . . in Death Valley . . . from one inch to a foot in depth . . . [but] their location is in the center of a most inhospitable region and distant from any practicable thoroughfare." But three years

later, the Southern Pacific Railroad would arrive at Mojave, California; the distance from Death Valley was 165 miles, only 15 miles more than the road from Columbus to Wadsworth and just five miles more than the road from Teels Marsh. Death Valley's borax fields could finally be mined, but first they had to be claimed. This challenge would fall to a couple that lived in a small mud hut at a spring in the Amargosa Valley east of Death Valley.

Aaron and Rosie Winters lived a simple life, but one day in 1881 a wandering prospector came to their hut and told them of the rich borax fields of Nevada. He also told them that the way to test for borax was to place the suspected rock in a solution of alcohol and sulfuric acid, and light the mixture on fire. If it burned with a green flame, borax was present. Aaron remembered seeing a suspected deposit in Death Valley. He took his wife, Rosie, with him one day, camped in the valley, scooped up some of the salty white substance, and performed the test—the solution burned green. Winters immediately sought out both William Tell Coleman and Francis [Frank] Marion "Borax" Smith. Coleman and Smith sent men to investigate the claims, and the deposit was indeed rich with borax. Winters had rediscovered the deposits mentioned in the *Scientific American* in 1873. He sold the claims for $20,000 to William Coleman, who now made the decision to become not just a distributor but also a borax producer. Coleman set up the Amargosa Borax Works in the Amargosa Valley, where one deposit was found, and the Harmony Borax operation, where the other was discovered in the heart of Death Valley. By 1883, mule teams were hauling borax out of both Amargosa and Death Valley, just as they had been doing in Nevada since 1872. But Coleman's operations would not last long: five years later, he went bankrupt, and the Death Valley and Amargosa works shut down. Borax Smith bought the defunct mining sites, mothballed them, and opened his new borax mine more than 100 miles south at a place he called Borate in the mountains near the railroad town of Barstow in the Mojave Desert. Smith incorporated his new company, Pacific Coast Borax, in 1890, and in 1891 began his most aggressive marketing campaign using the writing talents of John Spears and the photography of Frederick Monsen.

It has been noted that all over the Nevada desert and at California's Searles Lake, and even during the Death Valley era, the method of freighting was referred to as "big teams" or "long-line teams," and no special reference in contemporary newspapers is made of Death Valley's twenty-mule teams. It required the marketing efforts and vision of both Stephen Mather and Borax Smith to take this ordinary form of transportation and elevate it to the iconic status of *the* "Twenty Mule Team of Death Valley."

One

THE WEST'S WHITE GOLD

Soon after gold was discovered at Sutter's Mill in California in 1848, Americans rushed westward. Hundreds of thousands came by boat or on overland trails seeking their fortune and a better life. Most came in 1849 and were called '49ers. They left the comforts of home and their lives as farmers, merchants, lawyers, doctors, and even preachers. Many brought their families, but others came as single men. One pioneer later wrote that all he could think of was the sumptuous food on his father's table back East while starving and plodding through the great American desert. It was the dream of finding gold, or "color" as the prospectors called it, which drove the pioneers west. But the gold they were seeking did not last long, as the best locations were quickly staked and claimed. Gold found in the streambeds was largely picked over, and by the mid-1850s miners were beginning to spread out from California and head east.

Ironically, in the rush west for "color," the pioneers had walked over, past, and around a mineral that was much needed in America. That mineral was white and was called borax. It would later be found in the dry lake beds of the Nevada and California deserts. These lake beds were cursed by pioneers because deceptive mirages often gave the barren salt flats the appearance of being filled with much-needed water. Yet it would be those very dry and cursed lake beds that would give rise to an entire industry and create some of the largest fortunes in America. Borax was expensive and was imported mostly from Tibet and Italy. There was no domestic source of the product at the time, and it was needed by blacksmiths to make welds secure, by glassmakers to shape glass, by those who made decorative enamel or porcelain glazes, and by druggists throughout the country for a variety of medicinal, hygienic, and food-preservative uses. It would be the failure of at least one gold-rush pioneer that would lead to the discovery, exploitation, and marketing of the West's "white gold."

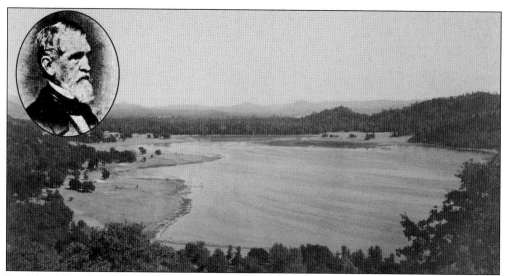

Dr. John Allen Veatch headed west after he married in Kentucky in 1833. He went first to Texas, where his wife died. In 1844, he joined the fight for Texas independence under Gen. Sam Houston. He remarried and in 1849 caught "gold fever." Taking the journey overland, his small group of men, including his son Andrew, nearly starved. Had it not been for a friendly band of Native Americans who guided them, Veatch may never have made it. He was one of the few who made a "snug sum of gold" in the gold rush and was also a student of botany and chemistry. In January 1856, at this lake (now called Borax Lake), Veatch made the first borax discovery in the United States. (Insert courtesy of Allen Public Library, Fort Wayne, Indiana.)

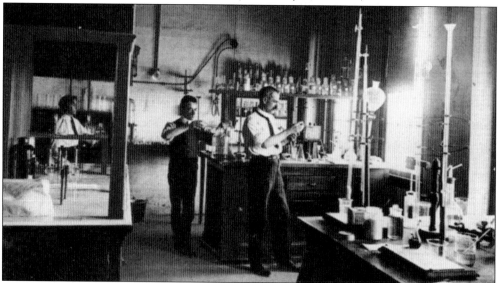

When Veatch visited the lake, he was curious about the water's medicinal properties, as springs near the lake had been used as a resort. Veatch took a sample of the water home to San Francisco and presented it to two world-renowned chemists in a lab similar to the one pictured here (a later borax facility). They tested the water, and it contained a small amount of borax. He asked them to produce a borax crystal from the sample, but they said it could not be done. According to *The Veatch Family in America*, Veatch persisted and used some of his own chemicals to "turn out a button of a borax crystal!"

Veatch returned to the lake and pulled out perfect crystals of pure borax (at right) weighing up to a pound each. In 1864, Veatch and a partner established the Borax Company of California, the first borax company in America. It lasted five years, producing 220 tons in one year at its peak.

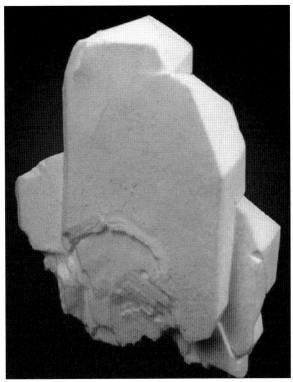

Meanwhile, in 1859, silver was discovered on the side of a mountain in northern Nevada, giving rise to the legendary Virginia City (pictured). Thousands were drawn to the new boomtown, as it became the hub for prospectors seeking the next big strike. Among them was William Troup. (Courtesy Nevada Historical Society.)

In 1860, Troup was prospecting on the California-Nevada border near Mono Lake when he met John Veatch. Like visitors today, the men must have been fascinated with the odd formations of tuff rising from the lake. Veatch suspected the lake contained borax, and after a test his hunch was confirmed. He told Troup, who quickly ventured into the Nevada desert looking for borax. (Author's collection.)

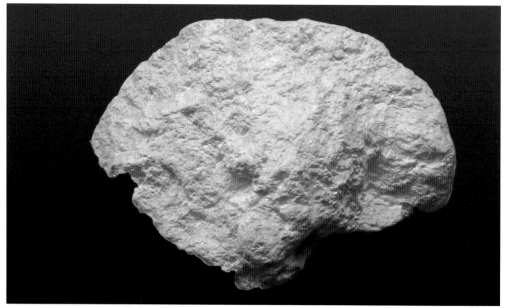

Eleven years later, Troup found ulexite, or "cottonball," borax on the dry lake bed at Salt Wells near Fallon, Nevada, and at Columbus Marsh near present-day Tonopah, Nevada. Cottonball borax (seen here) was found on the surface of many of the same dry lake beds that pioneers cursed on their westward trek years earlier.

Troup's discovery at Columbus Marsh brought prospectors and miners rushing to every suspected salty playa in Nevada. Samples of ore made their way into the hands of Emile Stevenot, a Frenchman who came to California in 1863. Stevenot confirmed the presence of borax, and in 1872 he set up a mining operation at Columbus Marsh called the Pacific Borax Company.

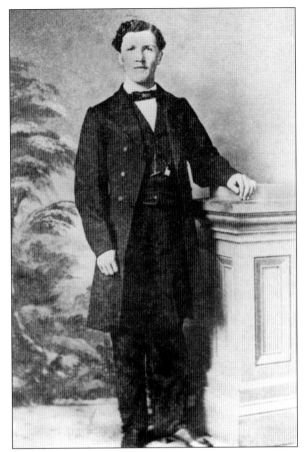

Like most mining operations, the Pacific Borax Company operated its own company store. The store was located in Columbus itself, while the borax operations were about five miles south of town. (Courtesy Central Nevada Historical Society.)

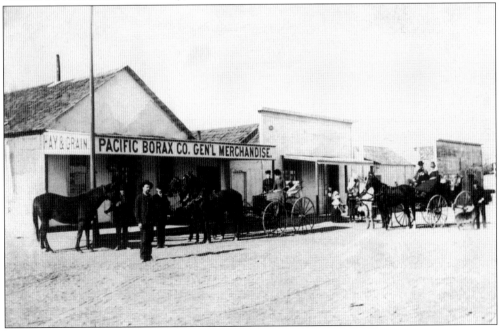

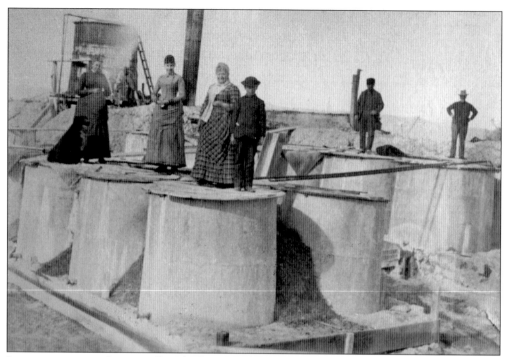

Large vats were used to crystallize the borax at the Pacific Borax Company. The people seen here are standing on lids placed over the vats. The borax would crystallize on the inner walls of the vats and was scraped off, dried, and loaded into sacks. (Courtesy Central Nevada Historical Society.)

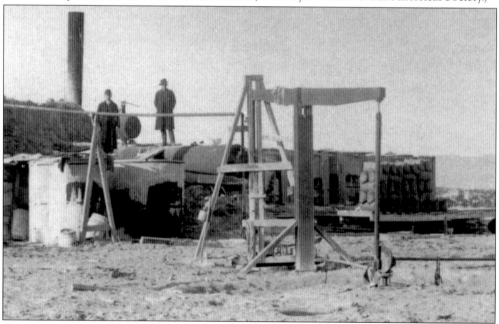

This early photograph of the Pacific Borax Company operation shows the smokestack for the boiler. The boiler heated a liquid, removing impurities and creating a solution that was sent to the vats. Sacks of borax can be seen here ready for shipment to the railhead about 150 miles away. (Courtesy Central Nevada Historical Society.)

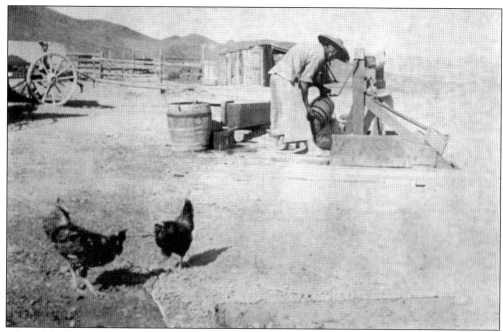

The gold rush of 1849 brought thousands of Chinese immigrants. While many prospected, others set up service businesses such as restaurants and laundries. Remote mining operations brought in Chinese laborers known for their willingness to work cheaply and in harsh conditions. Here, a laborer tends to his chickens at Columbus Marsh. (Courtesy Central Nevada Historical Society.)

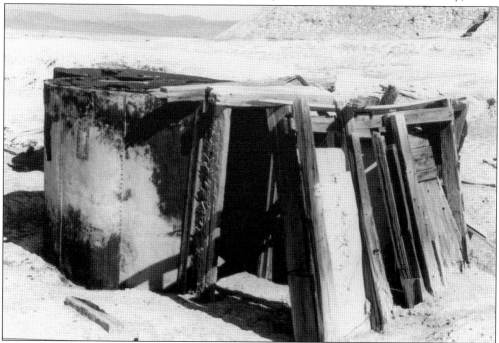

Living conditions for early miners were often primitive, but at Columbus Marsh Chinese laborers sometimes lived in tiny quarters made from old or unused vats. The vats were primarily used to crystallize borax but were repurposed as a crude shelter. (Central Nevada Historical Society.)

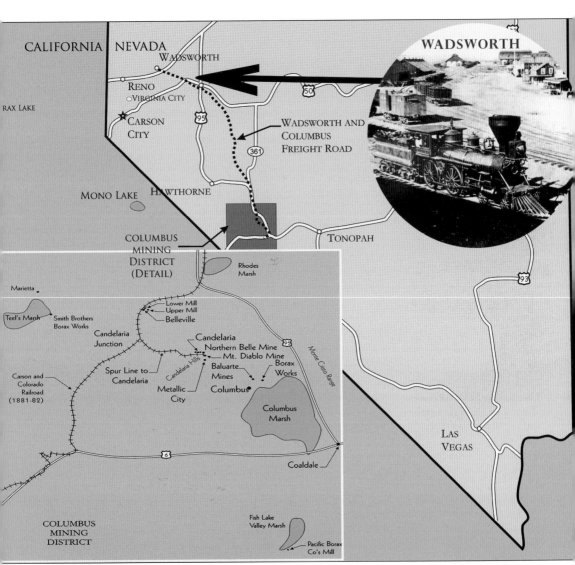

When the Central Pacific Railroad reached Wadsworth, Nevada, in 1868, it made borax production possible. The insert map shows the four primary borax operations of Nevada in the 1870s through the 1890s: Columbus Marsh, Teels Marsh, Rhodes Marsh, and Fish Lake Valley. The road to the railhead became known as the Columbus to Wadsworth freight route. The station at Wadsworth, seen here in 1869, was later moved near Reno, becoming the town of Sparks. (Map courtesy of the Bureau of Land Management; insert, Nevada Historical Society.)

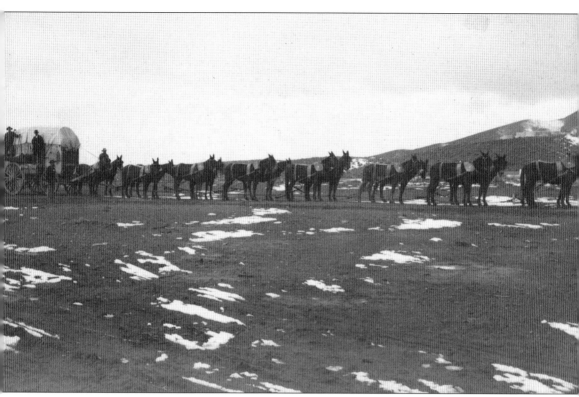

Teams of animals hitched in pairs, as in this early image of a 16-mule team in Nevada, were called "long-line teams" or "big teams." In the 1870s, Emile Stevenot's Pacific Borax Company and other borax operations used these teams to haul to the railroad at Wadsworth some 150 miles away. The *Scientific American* of September 22, 1877 reported, "The distance from Columbus, Nevada, the site of one of the principal deposits to Wadsworth, the nearest station on the Central Pacific Railroad, is about 150 miles over a desert country. The means of transportation is a train composed of three wagons, the pole of one fastened in the axle of the preceding. Twenty-four mules are harnessed to the first wagon. In this way the load of about 30 tons is distributed on the six axles, an important precaution, as the route lies over sandy plains and marshes, where roads are unknown. When a difficult place is reached the three wagons are separated and the whole force of mules is attached to one vehicle at a time, which is thus hauled over or through the obstacle. Generally the owner of the train conducts it, sided by one or two assistants and in the last wagon is stored the necessary provision, which includes both food and water, for men and animals." A further description of borax teaming is given in the January 16, 1877, *Nevada State Journal*: "A peculiarity of mining camps and towns is the long line of six, eight, ten and twelve-mule teams, with the ponderous wagons. The Eureka Republican says some have their jingling bells on the leaders, pointers and wheelers; others depend on the well known voice to strait the obedient animals on an up-grade; while others still put more faith in 'stone whip-lashes' and the keen crack of the black-snake [whip], wielded with good effect. These teamsters are among the hardiest of our population." While whips were often carried by teamsters and rocks and pebbles thrown to motivate the mules, most teamsters were often soft-spoken in dealing with their animals and respected the temperament of their mules. (Courtesy University of Nevada, Reno Special Collections.)

In 1872, Francis Marion Smith had been roaming the West for five years washing dishes, prospecting, running a restaurant, and chopping wood. He had come from Wisconsin to seek his fortune but was not having much luck. One day, he stopped at the office of Emile Stevenot in San Francisco and asked for a job. Stevenot obliged and sent Smith off to chop wood for his borax operation in Columbus Marsh, Nevada.

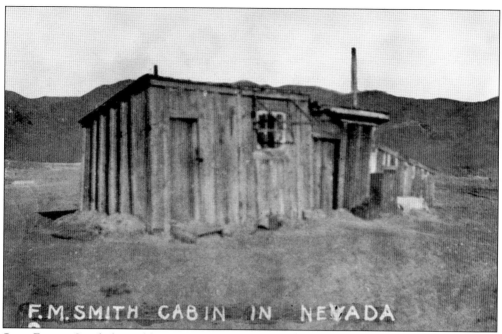

Soon Francis Smith formed his own wood-chopping company and located a good supply in the mountains nearby. In a later interview, Smith said that he had "erected a good, comfortable cabin in a narrow gulch, commanding a fine view of the outlying country. The view from the adjacent timber included the Columbus Borax Marsh which was being worked, also Teels Marsh, of which nothing was then known as a borax deposit." Smith had a photograph made of his cabin at Teels Marsh. (Author's collection.)

Smith explained, "From the hill-tops I could see the gleaming-white Teels Marsh, and taking two [of my wood] choppers one day, I visited the marsh and found a heavy incrustation, which, on testing, seemed rich in borax. It afterward appeared that we had chanced to step upon the richest portion of the marsh first." (Author's collection.)

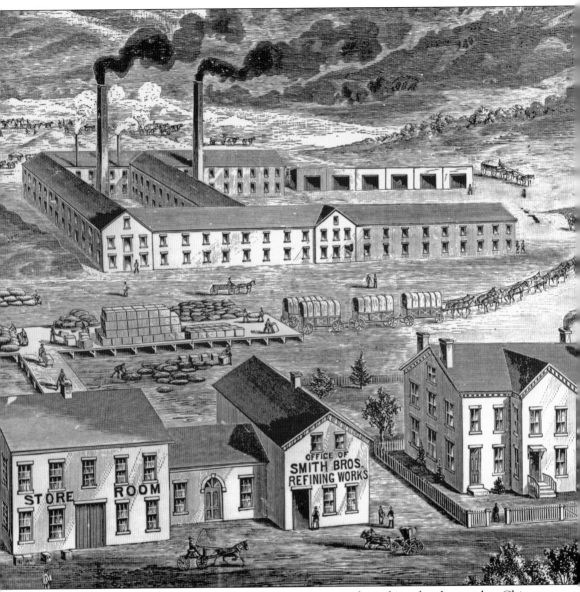

"As soon as possible," said Smith, "I made arrangements, through my brother, with a Chicago company, to put up a plant and the production of borax was begun. Borax was then little known beyond the blacksmiths and druggists and was costly, druggists selling it at 25¢ per ounce." Smith and his brother were determined to make borax a household item and devised imaginative advertising. Smith's processing plant looked nothing like the exaggerated image seen here: no such large structures existed on the Nevada desert. This image, however, was used on all packaging of Smith Brothers Borax. Note that in the center of the illustration, a team of mules pulls three wagons. Though Smith was unaware at the time, it was the foreshadowing of what would become an American icon.

Two

SHE BURNS GREEN

The May 31, 1873, issue of *Mining and Scientific Press* claimed that borax deposits were found at two or three different points in Death Valley. The paper said it was lying on the ground from one inch to a foot in depth and that "one of these deposits is in the immediate vicinity of the spot where those '49 emigrants abandoned their wagons but it is doubtful whether these new and extensive deposits will prove of any immediate value as they are near the center of a most inhospitable region and distant from any practicable thoroughfare."

It did not get much more remote than Death Valley: a narrow desert trough about 140 miles long and only about eight miles across at its widest. It had been dubbed "Death Valley" by some pioneers anxious to get to the California gold fields. Instead of staying on the route from Salt Lake City with their knowledgeable guide, a number of them decided to break off near what today is Enterprise, Utah, and head directly west. It landed them in one of the deepest, driest, and hottest desert valleys in the world. Fortunately, their trek took place in the winter of 1849–1850. As some of them were leaving the valley after nearly starving to death and having lost one of their party, they stopped and looked back, saying, "Goodbye Death Valley!" Variations of the tale were told enough times that it caught the attention of a journalist, and by 1861 the name was on the map.

It would be another 15 years until a railroad line even came close to the now notorious valley. With the arrival of the Southern Pacific line in Mojave in 1876, civilization was only a mere 165 miles away to the west. To the men who had been hauling borax more than 150 miles through the Nevada desert to the railhead at Wadsworth, Death Valley's borax deposits were now within reach. They simply had to be rediscovered.

The gold rush pioneers who struggled through Death Valley in the winter of 1849–1850 sought an escape from what they cursed as the "Creator's dumping place" or the "dregs of creation." Little did they know that the salty white surface they slogged over contained a fortune in borax. This 1891 photograph was included in a booklet distributed by Pacific Coast Borax and erroneously labeled as a remnant "left by the emigrants who perished while attempting to cross Death Valley." Only one emigrant perished in Death Valley.

John Searles and his brother Dennis came for the California gold rush of 1849. They, like most, found no gold but tried their hand at farming and mining. Eventually, they settled down to work some claims in the Slate Range of the northern Mojave Desert west of Death Valley.

In 1864, the Searles brothers found borax in the salty white playa that lay below the Slate Range, but they would not set up their borax operation for another nine years. Inspired by Francis Marion Smith's success at Teels Marsh in 1872, the Searles brothers set up their operation on the edge of the dry lake bed. (Courtesy Chris Austin.)

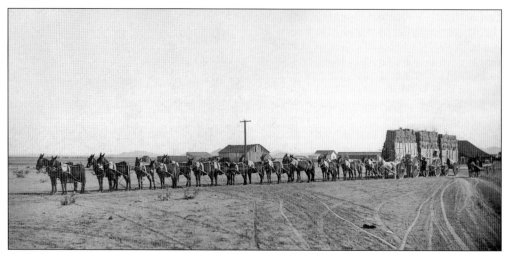

For the Searles operation, hauling borax was a 200-mile, 12-day trip from the plant to the port of San Pedro south of Los Angeles. The Searles Brothers used long-line teams with wagons hitched in tandem and often used 20 mules or more.

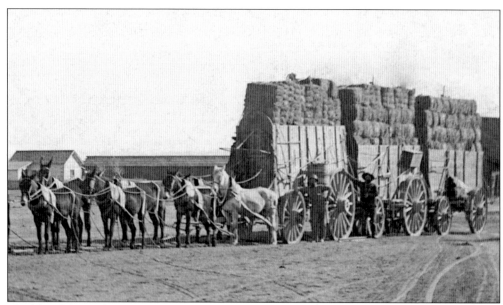

This detail shows the size of the wagons and the wheels. Note the load of hay. Once the wagons dropped off their loads of borax, they would load up with supplies for the return trip to the remote Searles Lake site.

East of Searles Valley and Death Valley lay the Amargosa Valley. Amargosa means "bitter water," referring to the underground river that flows the valley's length. It occasionally surfaces in streams and springs. It was at one of the springs called Ash Meadows where Aaron Winters homesteaded with his Castilian wife, Rosie, on a modest ranch. A visitor once described Rosie as "a delicate Spanish-American woman with frail health and little fitted for the privations of the desert." (Courtesy Joyce Yount Dangermond.)

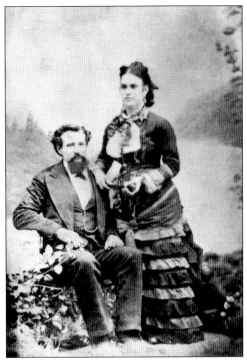

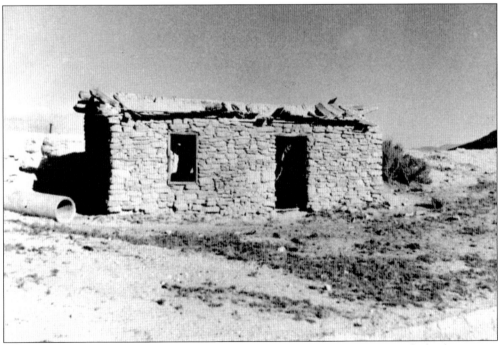

The Winters' home was humble to say the least. This photograph seems to match the description given by one visitor: "Close against the hill, one side half-hewn out of the rock, stood a low stone building, with a tule-thatched roof. Inside there was a flour barrel against the wall, a small bag of rice nearby and two or three sacks of horse feed in a corner. The sugar, coffee and tea were kept under the bed."

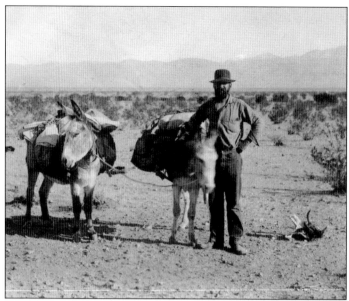

One day in 1881, a prospector named Harry Spiller stopped at the Winters' ranch for a rest. He had come down from the Nevada borax fields. Spiller showed Aaron and Rosie that if they found a rock they thought contained borax, just perform a simple test: add sulfuric acid and alcohol to the substance and light the mixture. If it burns green, it is borax, and riches would be theirs. While this image is not of Spiller, it is typical of the prospecting outfit of the era.

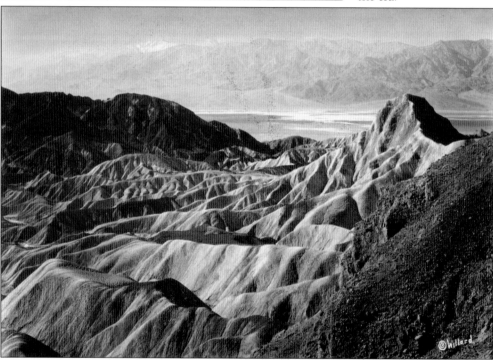

Aaron Winters thought he had seen borax in Death Valley. One night, he and Rosie camped at Furnace Creek wash before venturing onto the salty white floor of the valley. According to writer John Spears, "Winters was talking all the while and teetering and wabbling about, as was his habit when excited." Around the campfire, Aaron performed the test on some samples he scraped up, adding the sulfuric acid and alcohol to the salty white substance. He lit the mixture and "shouted at the top of his voice: She burns green, Rosie! We're rich, by God!" Aaron immediately sought out America's borax kings. This photograph from Zabriskie Point shows Manly Beacon (right) and the distant salt flats. (Courtesy Palm Springs Art Museum, Stephen Willard Collection.)

William Tell Coleman had a near monopoly on the distribution of American borax. He came for the gold rush of 1849 but found he could make more money by selling mining supplies and homemade apple pies to sweet-toothed miners. By 1881, he had developed an international distribution business. Born in Cynthiana, Kentucky, his natural alliances were thought to be southern, yet during the lead-up to the Civil War he believed the Union should be saved and fought to keep California a Union state. In 1856, he led the Vigilante Committee in San Francisco, keeping law and order. In the 1880s, newspaperman Charles Dana of the *New York Sun* supported nominating Coleman to defeat Pres. Grover Cleveland. (Courtesy California State Library.)

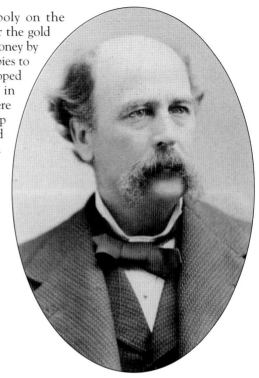

Coleman owned a fleet of clipper ships and specialized in the distribution of canned goods, such as salmon and fruits. He controlled the Pacific Coast sales of Royal Baking Powder, Baker's Chocolate, and Kingsford Starch. He invested heavily in markets that he believed he could corner or control. It would later prove to be his undoing. For now, he was interested in the Winters' claims, and he and his producing partner Francis Marion Smith were ready to make a move. (Courtesy Australian National Maritime Museum.)

29

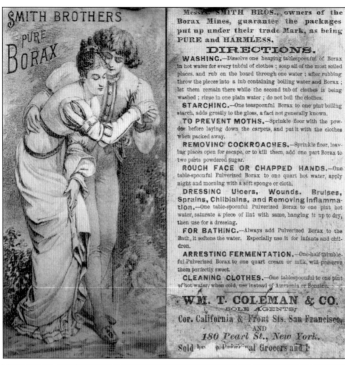

After Smith found borax at Teels Marsh, he went into the borax production business with his brother Julius. They soon established a working relationship with William Tell Coleman, and he became their major distributor. This early trade card not only illustrates the early uses of borax, but it also shows the relationship between Coleman (distributor) and Smith (producer). (Author's collection.)

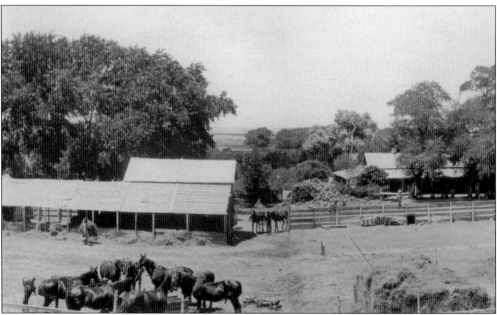

Smith and Coleman sent their agents to investigate the Winters' claims. They were indeed rich. They set up the Death Valley Borax and Salt Mining District and purchased the claims for $20,000. With that money, Winters purchased the Pahrump Ranch, only six miles from the Manse Ranch (seen here). One member of the Yount family recalls that Aaron brought Rosie to the nearby Manse Ranch when she was not feeling well. It was not long after that Rosie died, and Winters lost the ranch to back taxes. He lived the rest of his days as a hermit in the mountains. (Courtesy Joyce Yount Dangermond.)

Three

DEATH VALLEY'S BIG BUSINESS

William Tell Coleman had been heavily involved in the Nevada borax operations since the early 1870s. When Emile Stevenot's Pacific Borax Company collapsed in 1876, Coleman bought it and for a while took over the operation. Later, in 1880, he sold it to Francis Smith. By 1881, Smith was poised to own nearly all of the major borax-producing marsh facilities, with his primary operations at Fish Lake Valley and Teels Marsh—he was truly the borax king. The relationship of Coleman as distributor and Smith as producer created a formidable business team, but each retained their own separate businesses. Coleman was an ambitious man himself, and he never seemed content. He saw the new claims purchased from Aaron Winters as an opportunity to become a producer himself. In order to make the Death Valley claims pay, Coleman relied heavily on Smith's expertise and the outstanding mining men he employed. Among them were Rudolph Neuschwander, John Ryan, and Christian Zabriskie, who had been with Smith since 1873 at Teels Marsh.

Not only did Coleman have the best borax mining men and engineers in the country working for him, but he was determined to monopolize borax in the Death Valley country. Soon after Coleman bought the Death Valley claims, Winters found more borax in the Amargosa Valley to the east of Death Valley and sold them to Coleman as well. Coleman then sent his mining engineers out to stake as many claims in the Death Valley country as they could find. Coleman's vast resources would ultimately help to establish one of the most efficient and productive borax ventures in the West. He was determined to become a major borax producer and tried to head off any possibilities of nearby competition. Coleman had to contend with the Searles brothers two valleys to the west, but before he could ship an ounce of borax, a competitor showed up in his backyard.

Isadore Daunet was a Frenchman who had wandered into Death Valley in 1880 with some other prospectors, barely escaping with his life. When he heard about the Winters' success in 1881, he was convinced that he had seen similar salt flats south of their claims. He returned with some partners in 1882 and staked claims, establishing the Eagle Borax Works. In June 1882, Daunet shipped the first borax out of Death Valley on pack mules. Later that year, the first wagonload would be hauled from Daunet's crude refinery to the railroad at Daggett, California, by a driver named Ed Stiles.

Daunet's operation succeeded in producing over 130 tons of borax until June 1883. When the summer heat set in, the borax could not crystallize, and the operation was shut down. Daunet was newly married and was now falling behind financially. By the time the operation reopened, he was nearing bankruptcy. Upon returning to San Francisco the following spring, he found his wife had left him. It was all too much, and according to the papers, Daunet "sat down, tied a white handkerchief around his head . . . and blew his brains out." Shortly after, Coleman purchased Daunet's operation, letting it fall into ruin. The remains of Daunet's home at his Eagle Works are pictured here in 1891.

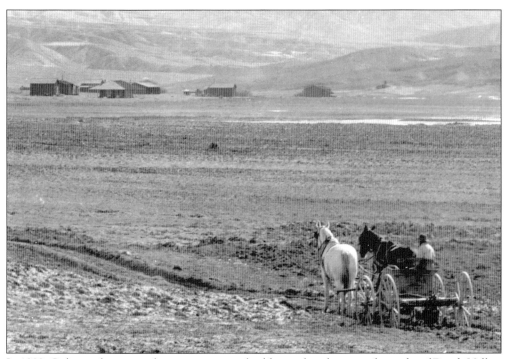

In 1882, Coleman began sending equipment to build a crude refinery in the midst of Death Valley. The little settlement of Coleman was established, and by early 1884 the Harmony Borax Mining Company was ready to ship its first load of borax. In this image, mining engineer and long-time borax man John Ryan approaches the Death Valley settlement and borax operations.

There was water to be found in the notorious "valley of death"—enough to support a ranch. Seeds were brought in to grow crops and seedlings for trees. The ranch was developed into one of the greenest oases in the desert and was called, appropriately, Greenland Ranch.

Author Carl Glasscock, in his 1940 book *Here's Death Valley*, describes Greenland Ranch: "Trees were planted—palms and cottonwoods and willows. . . . Barbed wire fences, strung around to keep out the burros and other animals." (This item is reproduced by permission of the Huntington Library, San Marino, California.)

Forty acres of alfalfa fields were laid out, irrigated, and planted. Before any borax was produced, the alfalfa was harvested.

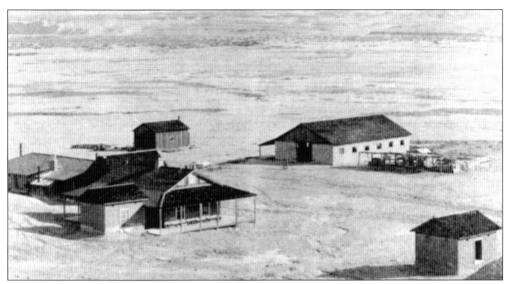

Coleman set up two separate mining operations. There was Harmony, at the site of Coleman in Death Valley, and the other was in the higher elevation of the Amargosa Valley, about 60 miles to the east. The Amargosa borax site was discovered by two other prospectors who took their claims to Winters. Winters, in turn, sold the claims to Coleman and split the money with the other men. Though the operations were at first titled separately (Harmony and Meridian), according to historian Richard Lingenfelter both the Death Valley and the Amargosa (seen here) operations were consolidated into one firm called the Harmony Borax Mining Company on May 15, 1884.

The Amargosa Borax Works was built on a hillside like all other borax plants of the day. This was the first of Coleman's operations to produce refined borax. The Amargosa Valley was cool enough in the summer to allow the borax to crystallize in the vats. In the summer of 1883, Coleman's first mule-team shipment departed from the Amargosa works. (This item is reproduced by permission of the Huntington Library, San Marino, California.)

On March 20, 1947, Sam Yount gave a personal account of his work at the Amargosa Borax Works. In the 1880s, he went to San Francisco to take a business course, but he ran out of money and had no way of getting back home to his family's Manse Ranch in the Pahrump Valley. His father had sold some claims to William Coleman, and Sam used the connection to arrange a meeting in San Francisco. Coleman gave the young man $50, charging it to the Amargosa account. When Sam arrived in Pahrump, he headed to the Amargosa Works and applied for a job to work off the debt. (Courtesy Joyce Yount Dangermond.)

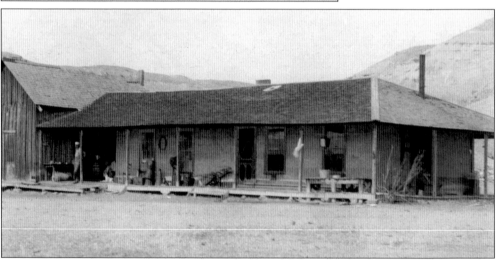

Yount was paid $3 a day at the Amargosa Borax works, and $1 was taken out for board. He was a clerk and general utility man and likely worked out of the building shown here. He also checked the weight of the ore as it was loaded on to the wagons. As the plant was shutting down, Yount was left alone at this outpost for at least a month. He was to make sure that the ore remaining on the dump was shipped out by wagon to the railhead at Daggett. Every three days, a 20-mule team would show up for another load. Yount said he strained his eyes watching for them. He even cooked a pot of beans for the teamster and swamper. For him, it was the loneliest experience of his life, but he always looked forward to seeing the 20-mule team.

Getting men to work in Death Valley was a challenge. Some took one look at the place and quit. Coleman wanted men who could cope with the remote and harsh conditions. In a letter to Daggett merchant D.W. Earl, Coleman stated that he "wanted men who would stick. I want nothing to do with tramps." Of the 40 workers hired, 30 of them were Chinese. Their backbreaking work was scooping borax from the valley floor, loading it into handcarts, and then putting it into wagons to haul to the boiler.

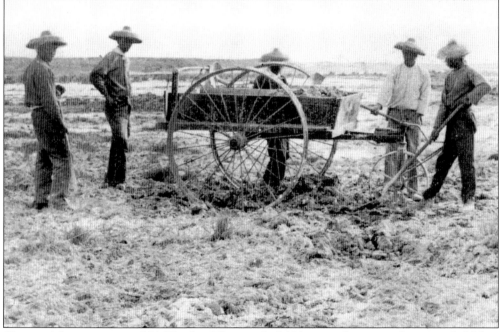

Chinese laborers were paid $1.25 a day. They worked 10 hours a day, seven days a week. If they came back for a second year, they got a raise of 25¢; few ever returned. For those who stayed and worked, much of what they made was spent at the company store, where they would purchase staples for living, including tea and rice.

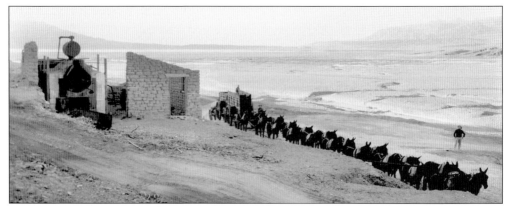

Once the borax was scooped up off the valley floor by Chinese laborers, it was brought to the dissolving tanks. In this photograph, the dirt road seen in the foreground was used by smaller wagons hauling borax scooped up off the playa by the Chinese to dump into the large boiling tanks just beyond the boiler. The boiler was located in the "machine room" made of adobe and sandstone about 20 feet long and 10 feet wide. The boiler itself was gigantic at 17 feet long and four feet in diameter. It was fueled by mesquite wood chopped and sold to the borax company by the Timbisha Shoshone Indians. The boiler heated the liquid in giant dissolving tanks in which the borax was placed. The process of extracting pure borax from the desert floor was not difficult but was labor intensive and time consuming. This image, shot by Burton Frasher in the 1930s, clearly shows the 20-mule team in an accurate reenactment position ready to depart Harmony for Mojave. (Courtesy Frashers Fotos Collection.)

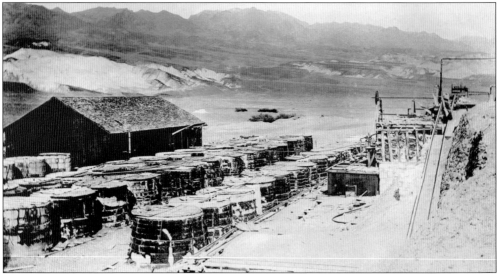

The two giant dissolving tanks held 3,000 gallons each (located on the hill out of frame to the right). In addition, the plant had eight settling tanks holding 2,000 gallons and 57 crystallizing tanks that held 1,800 gallons each. The borax was purified and refined, cycling through the process from the boiling tanks to rid impurities to the cooling vats where the borax crystallized. To keep the vats cool, they were often wrapped in felt that could be kept damp. The lids on the vats contained rods that hung down into the solution. It could take more than 10 days for the borax crystals to form on the sides of the vats and on the steel rods. The crystals were scraped from the tanks and rods, dried, and then placed in burlap sacks and stored in the warehouse until they could be shipped out.

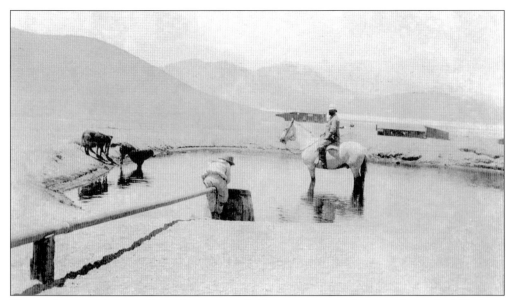

The entire operation was dependent on a reliable water source. A reservoir on the hill above the plant stored the water in tanks, and pipes took the water downhill to the facility. The water was piped in from several miles away, and there is also evidence that wells may have also fed the reservoir.

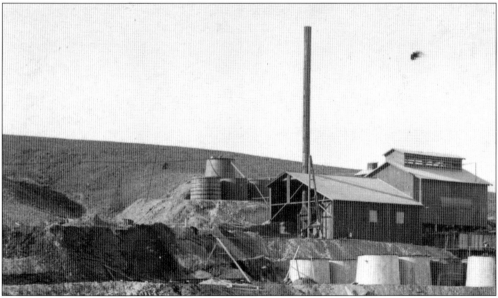

The Death Valley borax plant at Harmony began full-scale operation in the fall of 1883. The smokestack rising from the middle of Death Valley must have been an impressive sight. This detail clearly shows the pipes bringing water from over the hill behind the plant. The boiler is also clearly seen under the wood structure. The cooling vats are seen below the boiler building. By looking closely, a Chinese laborer can be seen to the far right above one of the vats. While the production of borax in such remote locations was now possible, the primary problem confronting Coleman would be transportation. (Courtesy Bancroft Library.)

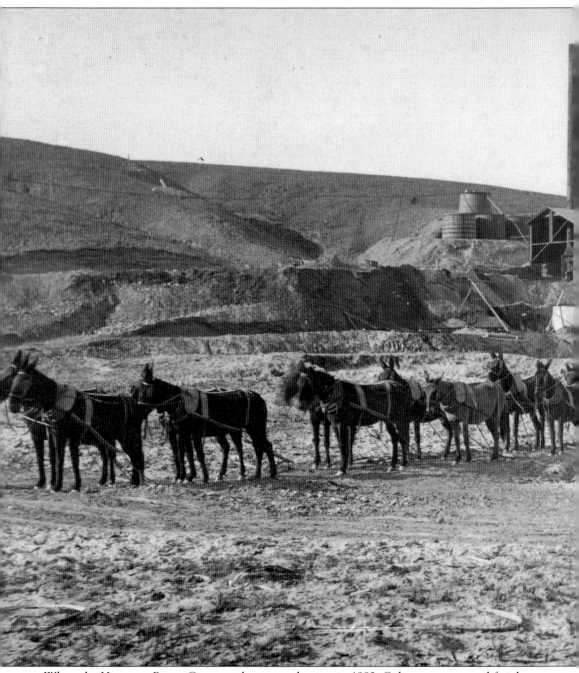

When the Harmony Borax Company began production in 1883, Coleman contracted freighter Charles Bennett. Bennett lived in Pahrump, Nevada, until he sold his ranch to Aaron Winters. He then moved to Daggett, California, on the route of the Atlantic and Pacific Railway. In the

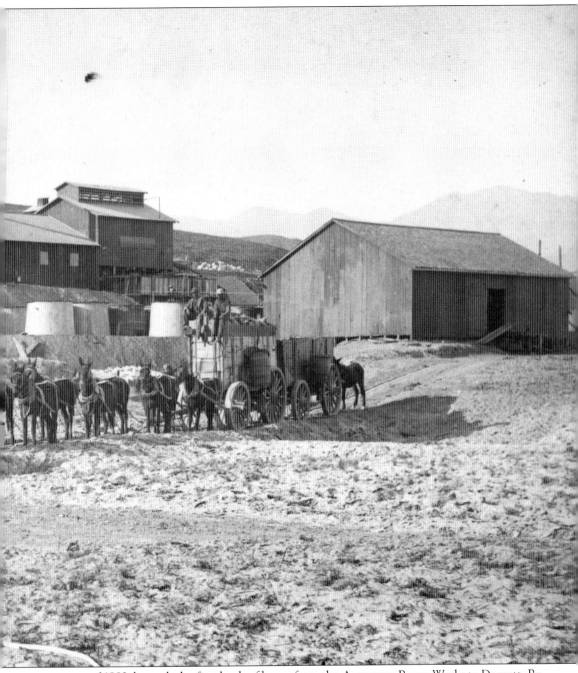

summer of 1883, he took the first loads of borax from the Amargosa Borax Works to Daggett. By the spring of 1884, Bennett had cut a better and faster route to the town of Mojave. (Courtesy Bancroft Library.)

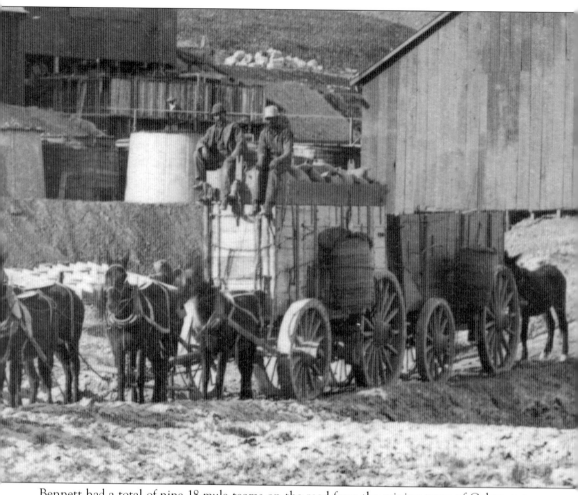

Bennett had a total of nine 18-mule teams on the road from the mining town of Coleman to the railroad town of Mojave. It was a distance of 165 miles and took 10 days one way. Borax was hauled out and supplies were hauled in, but it still was not quite good enough for William Coleman. (Courtesy Bancroft Library.)

Four

THE LARGEST WAGONS OF THEIR DAY

Charles Bennett had hauled for the Harmony borax operation for a year when William Coleman decided that he would not renew the contract. The price of borax was falling, and Coleman wanted to save money. He believed his operation would be more economical and efficient if he had his own wagons built, bought his own mules, and hired his own drivers. He would not have to look far for someone to supervise the building of the wagons. That job fell to John William Sampson Perry. Perry was a former druggist from San Francisco, and Coleman had recruited him to take over as foreman of the Harmony works.

Perry turned his attention to the desert transportation town of Mojave, California. Since the late 1870s, long-line teams of mules had been hauling to the railhead at Mojave from the California silver mining towns of Cerro Gordo, Panamint, Darwin, and the borax-mining operation at Searles Lake. In the fall of 1883, Coleman's operation itself had started hauling from Death Valley and the Amargosa Borax Works to Mojave. The little town of Mojave was a busy, bustling, dusty desert town full of all of the amenities necessary to refresh weary mules and mule drivers, and it had all of the equipment needed to repair and maintain wagons. Blacksmiths and wheelwrights could be found there, and if Perry needed wagons built, this was the place to do it.

Perry was looking for wagons that could withstand a rugged 165-mile, one-way trip from Death Valley to Mojave with a heavy load of borax and the return trip from Mojave hauling back supplies for a total of 330 miles. If Coleman was to save money, the wagons had to carry at least 10 tons of borax (20,000 pounds) each. Perry ordered five sets of wagons, and in 1884 construction began.

The earliest description of the wagons comes from author John Randolph Spears. His book *Illustrated Sketches of Death Valley and Other Borax Deserts of the Pacific Coast* was published in 1892 to help sell borax products. Though it was four years after the Death Valley operation had ceased, Spears was able to interview those who had worked during the Harmony borax era.

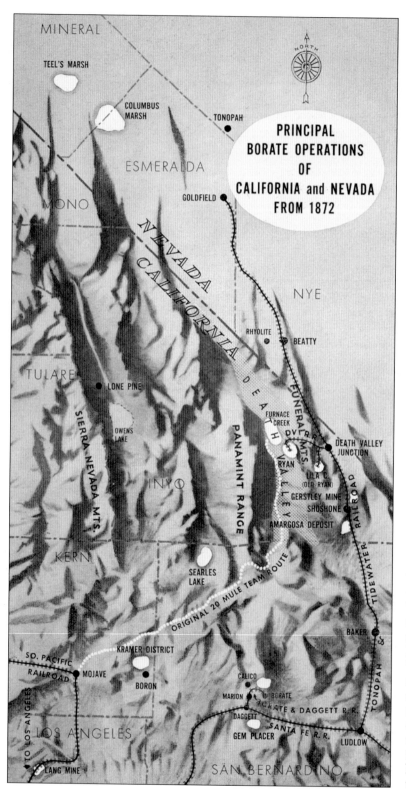

PRINCIPAL
BORATE OPERATIONS
OF
CALIFORNIA and NEVADA
FROM 1872

By 1884, the principal borax operations in the United States were Smith's Teels Marsh, Columbus Marsh, and Fishlake Valley operations; the Searles brothers' facility at Searles Lake; and Coleman's Harmony Borax Works. All of the operations were using long-line teams of mules, connected to wagons hitched in tandem, to haul to and from the railroad.

John William Sampson Perry was in charge of building the new wagons for Coleman's Harmony Borax Company. In a 1960 *Los Angeles Herald* interview with Perry's daughter, she said that her father's secretary told her about the "old teamsters who came to the office saying they were the ones who designed the wagons. None of them had any historical proof, of course."

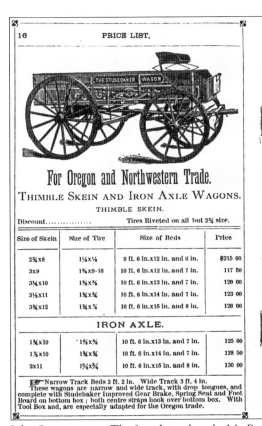

For Oregon and Northwestern Trade.

THIMBLE SKEIN AND IRON AXLE WAGONS.

THIMBLE SKEIN.

Discount............... Tires Riveted on all but 2¾ size.

Size of Skein	Size of Tire	Size of Beds	Price
2¾x8	1¼x¼	9 ft. 6 in.x12 in. and 6 in.	$215 00
3x9	1⅝x9-16	10 ft. 6 in.x12 in. and 7 in.	117 50
3¼x10	1⅝x⅝	10 ft. 6 in.x13 in. and 7 in.	120 00
3½x11	1¾x¾	10 ft. 6 in.x14 in. and 7 in.	123 00
3¾x12	1¾x⅞	10 ft. 6 in.x15 in. and 8 in.	126 00

IRON AXLE.

1¾x10	1⅝x⅝	10 ft. 6 in.x13 in. and 7 in.	125 00
1⅞x10	1¾x¾	10 ft. 6 in.x14 in. and 7 in.	128 50
2x11	1¾x¾	10 ft. 6 in.x15 in. and 8 in.	130 00

☞ Narrow Track Beds 3 ft. 2 in. Wide Track 3 ft. 4 in.
These wagons are narrow and wide track, with drop tongues, and complete with Studebaker Improved Gear Brake, Spring Seat and Foot Board on bottom box ; both centre straps hook over bottom box. With Tool Box and, are especially adapted for the Oregon trade.

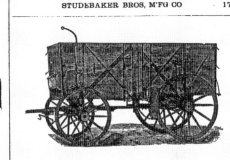

THE NEVADA
IRON AXLE WAGONS.

We are the only Manufacturers East of the Rocky Mountains who have ever made the

NEVADA STANDARD WAGON

so popular in that country.

We make these Wagons of sufficient capacity to carry 20000 pounds, and in dimensions as made and used in Nevada and California.

NOTE.—Being located in the midst of a heavy timbered country, we carry a very large stock of thoroughly seasoned Oak, Hickory, Ash and other timber adapted for special sizes, and are prepared to make any size Wagon on short notice.

John Spears wrote, "The first thing done by Mr. Perry was to obtain by inspection or correspondence, the dimension of all varieties of great wagons used by Pacific Coast freighters. With these . . . he proceeded to design the wagons." The Studebaker Company of South Bend, Indiana, was one of the companies producing wagons that Perry likely studied. The company's 1881 catalogue included a design called the Nevada Iron Axle Wagon, capable of carrying 10 tons. (Courtesy Studebaker National Museum.)

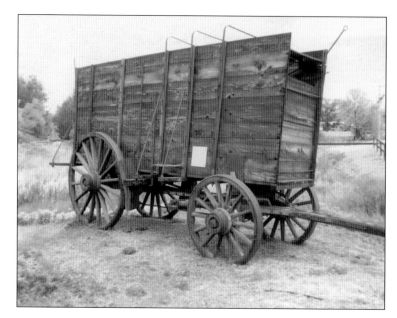

A Nevada ore wagon is on display at the Nevada State Railroad Museum in Carson City, Nevada. Its design is strikingly similar to Studebaker's Nevada Iron Axle Wagon. (Author's collection.)

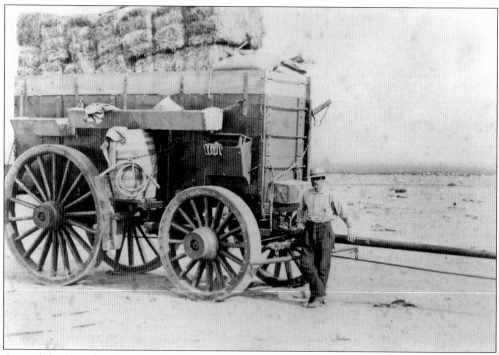

One of the large borax wagons is readied with supplies to head back out over the desert from Daggett in the 1890s. As compared to the ore wagon pictured at the top of the page, this wagon has 18 spokes on its rear wheels. One reason why the wagons lasted so long is that the wood was seasoned. Harold Weight writes in his booklet *20 Mule Team Days in Death Valley*, "The Death Valley wagons were made of hickory seasoned four years, and the hickory of the wheels was boiled in oil as part of its curing." (Courtesy Bancroft Library.)

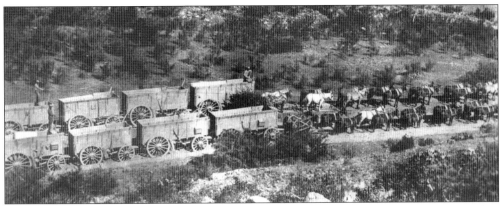

Long-line teams of mules hitched to wagons in tandem were used all over the West, including these from Arizona in the 1870s.

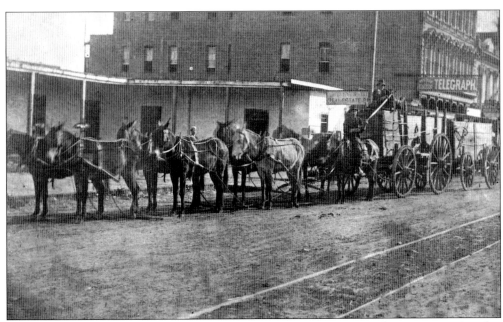

A freight team of mules pulling wagons in tandem could even be seen in downtown Los Angeles, California, in 1876. (Courtesy Los Angeles County Natural History Museum, Seaver Center.)

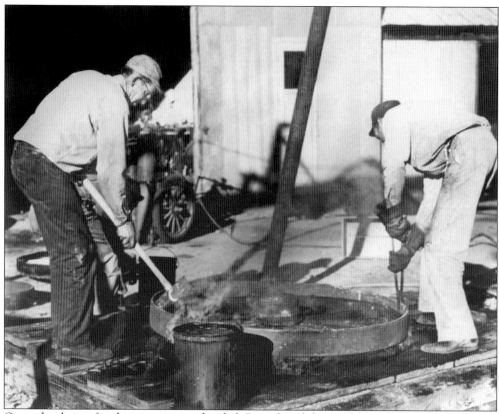

Once the design for the wagons was decided, Perry hired day workers in Mojave to make the wagons. Perhaps the most difficult part of the entire operation was making the wheels. The tires were made of iron. Borax man Dennis Searles wrote, "These tires are heavy pieces of iron and it takes a great deal of muscle to manage one of them. I tell you there is a great deal of puffing when the blacksmith is welding one of these tires. It takes about five or six men to manage one of them easily."

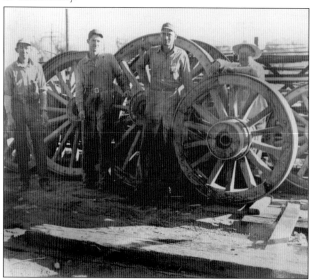

The wheels were extraordinarily heavy, weighing nearly 1,000 pounds each. John Spears wrote, "The hind wheel was seven feet in diameter and its tire was eight inches wide and an inch thick. The forward wheel was five feet in diameter." While, in later years, Spears and others in the borax company would claim that Coleman's wagons were the largest ever built, most knew the claim was false; however, the size of the wheels, and in particular the width of the tires, made them unusual and uniquely suited to desert conditions.

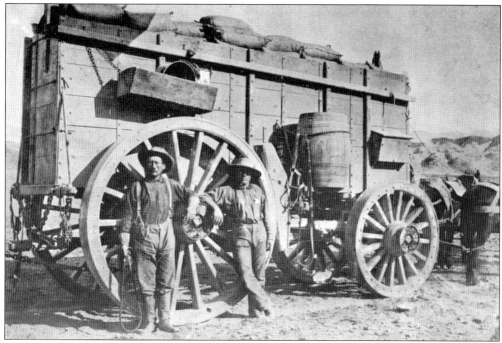

This is one of the few images of a loaded wagon during the Death Valley operation and probably dates to around 1885. Note that the borax in the wagon is in sacks, which indicates it was during the long-haul era from Death Valley to Mojave. On shorter hauls, the borax was shipped raw to the refinery. The teamster (left) is believed to be William Shadley, who died on one of his Death Valley hauls.

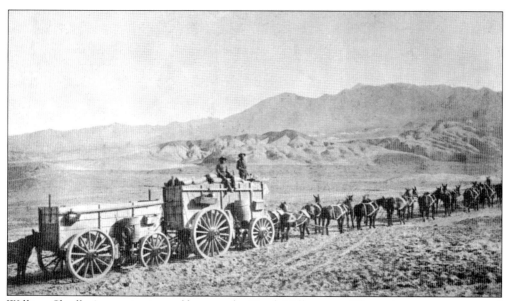

William Shadley's team is pictured here on the Death Valley route. The entire team was operated by only two men: the teamster (also known as the mule skinner) and the swamper (assistant/brakeman). The term "swamper" came from the men who worked on loading the wagons in the swamps of lumber camps in the Northwest.

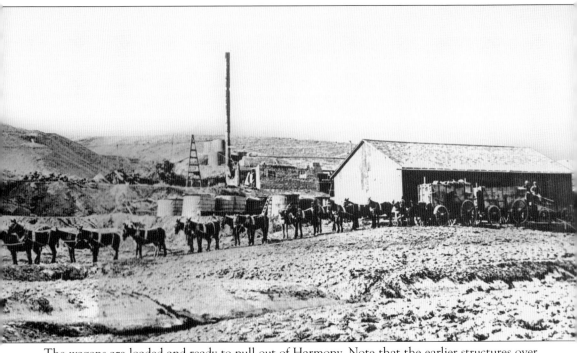

The wagons are loaded and ready to pull out of Harmony. Note that the earlier structures over the boiler are missing, most likely due to a fire. The fully loaded set of wagons, ready to be pulled (along with the 1,200-gallon water wagon, not shown here, but added at various places along the trip) would weigh 73,000 pounds (36.5 tons). John Spears wrote, "The wagon beds were sixteen feet long, four feet wide and six feet deep. The tread of the wagon—the width across the wheel—was six feet. Each wagon weighed 7,800 pounds, and the cost of the lot (10 freight wagons) was about $9,000 or $900 each." From the ground to the top of the wagon was approximately 12 feet. Note that it appears there are only 18 mules in this "20-mule team." It is likely this may be one of Charles Bennett's teams prior to the commissioning of the construction of the large wagons.

Five

THE AMAZING MULE

The animal best suited for desert freighting was the mule. Quite simply, the mule is a hybrid, the result of pairing a jack (male donkey) with a mare (female horse). Mules are sterile and can be either male or female, with a female often called a mare or molly and a male called a horse or john. No one is quite sure when the first donkey and horse got together to make the first mule, but they are mentioned in the Old Testament and in early Greek literature. In many ways, the mule is part of man's early technology, as it was bred specifically to work. The book *Wonders of Mules* describes them: "Surefooted, strong, smart and sound of constitution, the mule, which can be used for draft work, pack work and riding, combines the size of the horse with the endurance of the donkey." They can go without food and water longer than horses and can also withstand climate changes.

Mules are not stubborn animals as is commonly believed. Any mule skinner will explain that a mule simply is not as willing to trust its owner as much as a horse; that it is important to answer the mule's questions first before asking them to do anything, like, "Why should I do that?" or "Is it safe?" This sense of self-preservation is often illustrated with the example of a horse and barbed wire. A horse that gets tangled in barbed wire will thrash around, making the barbs sink deeper. A mule caught in barbed wire will stand still until it is released. Another example of the difference between horse and mule is their eating habits. Put a barrel of food in front of a mule, and usually it will eat only what is needed and leave the rest.

It was George Washington who first promoted mules in America. His belief in their usefulness was seen in an advertisement he placed in a Philadelphia newspaper in 1786. The ad boasted about "the great strength of mules . . . [their] longevity, hardiness and cheap support which gives them a preference of horses that is scarcely to be imagined."

In less than 50 years after George Washington promoted his mules, the animals had become widely used throughout the United States. Pictured here is a good breeding jack (male donkey). (Author's collection.)

Mules were put to all kinds of uses, and their intelligence made them excellent for plowing. Farmers often talk about how mules would not trample a row that had just been plowed and that their endurance allowed them to work during the hot, humid months of summer. Even President Jimmy Carter noted that in his youth he worked with Emma, the family mule, who knew "how to turn around at the end of a row and enter the next without stepping on the crop." (Author's collection.)

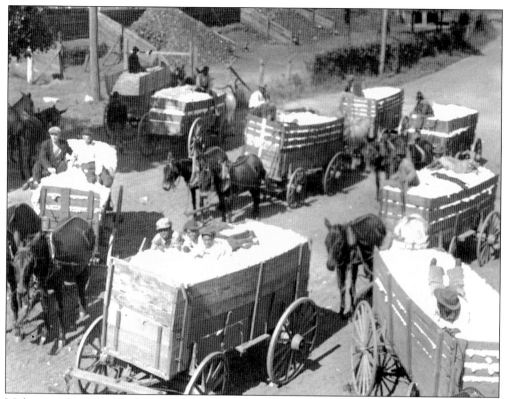

Mules were bred for specific industries. For example, sugar mules worked on sugar plantations, and cotton mules worked in plowing, planting, and transporting cotton. Sugar mules were large but light in weight. Cotton mules were the smallest mules used in farming. Here, wagons of cotton are brought to the cotton gin to be cleaned and readied for market in the 1890s. (Author's collection.)

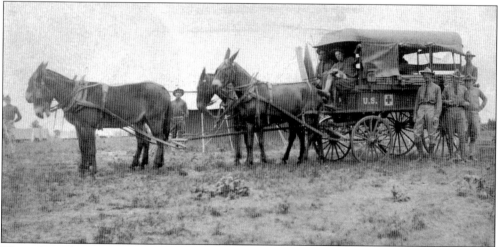

The military has used mules ever since the war of 1812. Here, two draft mules, the largest type of specially bred mule, pull a 1915 US Army ambulance. Today, the mule is still put to use on special occasions for the armed forces and remains the mascot of the US Military Academy at West Point. (Author's collection.)

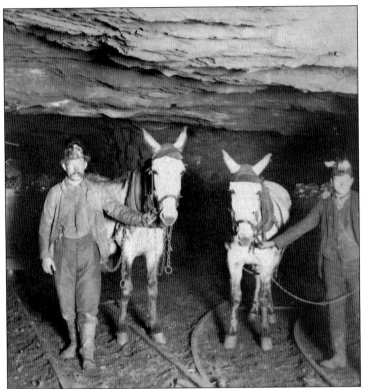

One of the smallest types of mules bred was the mine mule, as seen in this Pennsylvania mine in 1900. They were used to haul ore and supplies in the underground mines. Sadly, once the mules went below the surface, they often never again saw the light of day. (Author's collection.)

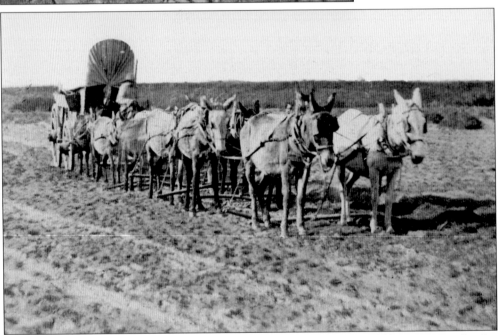

The breeding of mules involved pairing various types of horses with different types of jacks. The sizes of each would determine the size of the resulting mule. One of the most prized was the Missouri mule, because it is well proportioned and considered stylish. Smaller mules, however, from mustang or thoroughbred stock, were preferred for the long trip west. (Author's collection.)

Getting supplies into remote, mountainous locations took the skills of the pack mule. There could be several pack mules in a train, and they were often led by a mare with a bell, called the "bell mare." The mules in the far rear of the train could hear the bell and would follow the sound. Bells came to be used on long-line teams, serving as both a warning to other teams and providing a cadence to which a team pulled. (Author's collection.)

The sign on this mule's back reads, "I helped to build Pike's Peak's Railroads." In fact, pack mules brought in heavy loads of construction equipment and supplies throughout the mountains of the West. (Author's collection.)

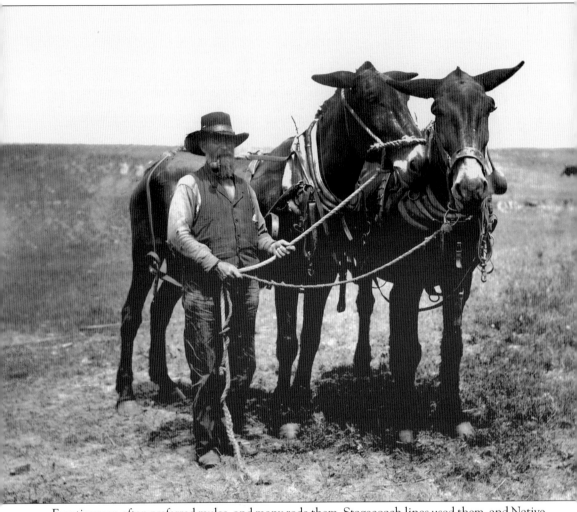

Frontiersmen often preferred mules, and many rode them. Stagecoach lines used them, and Native Americans valued them. Western movies do little justice to the use of the mule in the real West, and cowboys could sometimes be seen riding their mule instead of a horse. (Author's collection.)

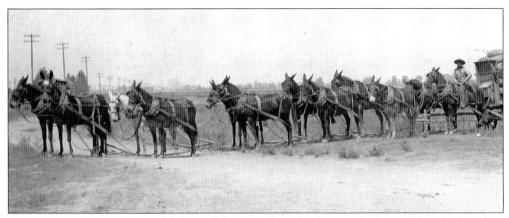

Here is a long-line team most likely used for agriculture hauling in the late 1800s. The long line referred not only to the line of mules but to the single line that the driver used to operate the team. Here, clearly visible from the driver to the lead left mule is the line called a 'jerk-line." It was named because of the jerking motion the driver used to turn the team. (Author's collection.)

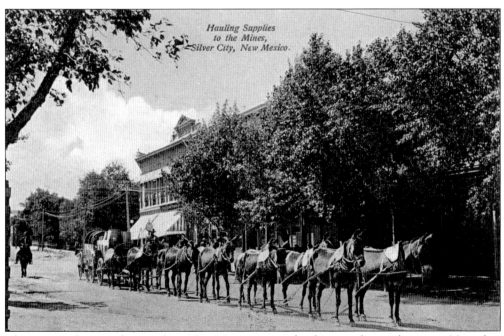

This image of a 12-mule team from New Mexico is seen hauling supplies to the mines. Note that in every long-line team, the driver is on what is called the "nigh" wheeler, or the horse or mule on the left side of the wagon tongue. This is the position from which the teamster operates. (Author's collection.)

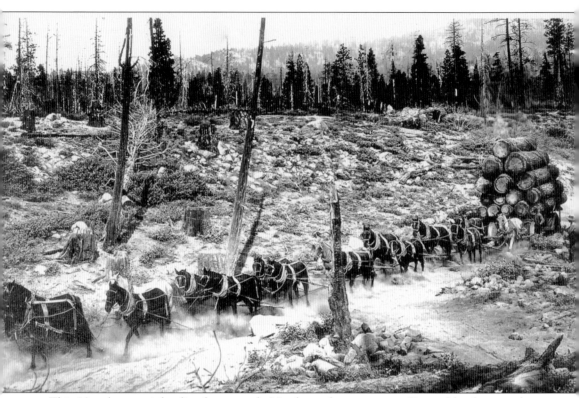

This 16-mule team is hauling logs out of a Northwest logging camp. Camps like this are where the term "swamper" originated. (Author's collection.)

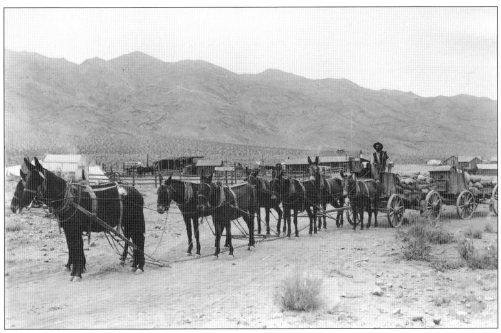

On this 8-mule team from the late 1890s, the jerk-line can plainly be seen going through loops on the mules to the lead mule on the left. (Author's collection.)

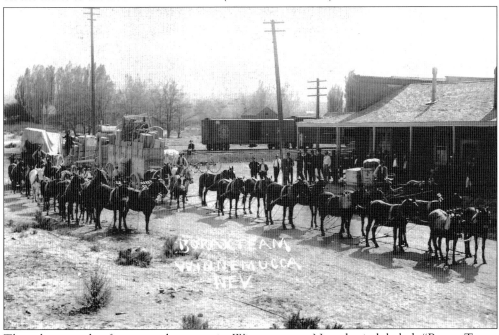

This photograph of some mule teams in Winnemucca, Nevada, is labeled, "Borax Team, Winnemucca, Nevada." It was likely labeled long after the photograph was taken, as borax wagons would have no reason to travel to far off Winnemucca in north central Nevada. In Nevada, borax was shipped to Wadsworth nearly 140 miles southwest of Winnemucca. This label illustrates that after the 20-mule team became well known, nearly any long-line team was associated with 20 Mule Team Borax. (Author's collection.)

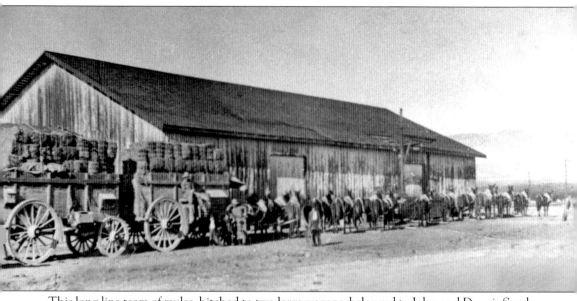

This long-line team of mules, hitched to two large wagons, belonged to John and Dennis Searles. The team is seen at the Searles supply barn in Mojave, California, in 1885. The little town of Mojave was a busy crossroads, as teams from mining camps from all over brought their ore to the railhead. For the Death Valley operation, Mojave was also the final destination for the borax men and their big teams. Today, the wagons here are on display not far from Mojave at the California City Police Department. (Courtesy Phil Serpico, Omni Publications, Palmdale Public Library.)

Six

ONE HUNDRED AND SIXTY FIVE MILES THROUGH HELL

The difficulties and dangers of the Death Valley route were later exploited and exaggerated by Pacific Coast Borax as a way to sell soap. For drivers who hauled from 1883 to 1888, the trip had its difficulties but no more than other desert freighting roads. What is truly fascinating are the factual details of the operation: there were five sets of wagons coordinated like a well-oiled machine over great distances, with only two men and 20 animals on each crew.

Hitching mules to the wagons was the task of the teamster. The only written account comes from John R. Spears, who did not see the Death Valley operation but saw a short 11-mile haul from Borate to Daggett in the 1890s. Spears describes horses in the hitch next to the wagon tongue, but it is likely they were only used on the short haul (1890s) and not in Death Valley (1883–1888). Nevertheless, Spears pens a most-colorful description: "The horses and mules are harnessed up in pairs. The horses are attached to the wagon at the tongue, and a great handsome 2,800 pound team it is. . . . Ahead of them stretch the mules. . . . The most civilized pair are placed in the lead and the next in intelligence just ahead of the tongue, while the sinful, the fun-loving, and the raw-hides fill in between."

He also describes a braided cotton rope a half inch in diameter, called a jerk-line, which runs from the left lead mule to the teamster about 120 feet. Spears further describes the teamster as he prepares to head off into the desert: "To see him soar up over the front wheel to his perch, tilt his hat back on a rear corner of his head, gather in the slack of the jerk line, loosen the ponderous brake, and awaken the dormant energies of a team with 'Git up . . . Git UP!' . . . is the experience of a tourist's lifetime." And off the wagons would go, pulled by the mules and guided by the teamster.

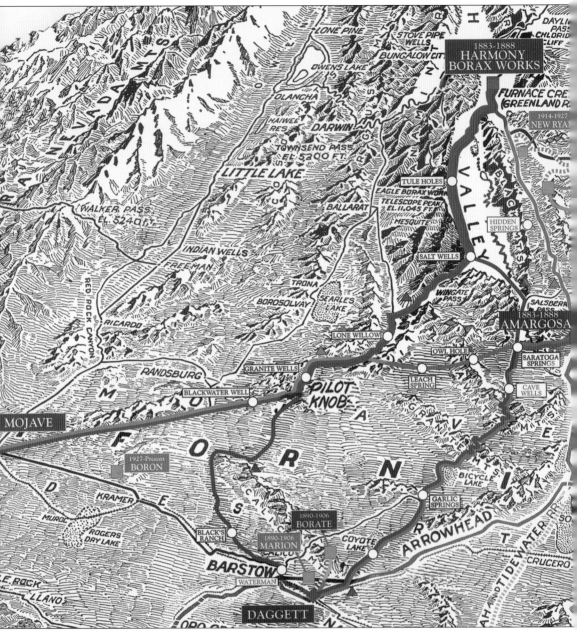

The four primary terminals of the historic Death Valley borax operations are seen on this map. It was produced by the author while serving as historical consultant for US Borax. Harmony Borax Works is prominent in the top right corner. At the far right center is Amargosa Borax Works. At the bottom center is Daggett, the first railhead terminal for borax shipped from Death Valley and Amargosa to meet the Atlantic and Pacific Railroad (later the Santa Fe). To the far left is the town of Mojave. In 1884, the route was cut directly west from Pilot Knob (center of the map), which was a natural landmark used to guide drivers on the route. The new route linked to the Southern Pacific Railroad in Mojave and cut the journey by a day. It had been an 11-day trip from Harmony to Daggett, and the section south of Pilot Knob, through the mountains, was particularly dangerous. (Author's collection.)

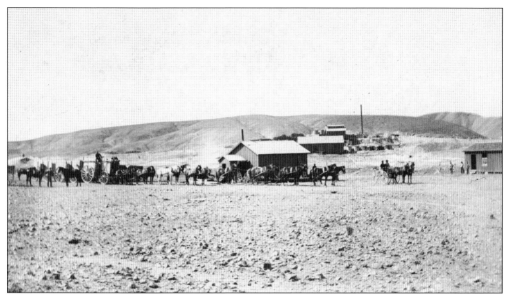

Here, a team can be seen pulling into the Harmony Borax Works. The image is significant, as it illustrates the industrial precision of the operation. Dean Lemon, in the 2000 '49er keepsake *The Harmony Borax Works of Death Valley, California*, states, "There were five sets of wagons used and plant production rates would indicate that a team would have to leave Death Valley every four to five days. This means that at least four and sometimes all five would be on the road at the same time and that teams going must often have had to share a camp with teams coming. It also means that after a team returned from Mojave to Harmony they would have three to five days to rest up, get the wagons and harness repaired, the mules shod and the wagons loaded." (Courtesy Bancroft Library.)

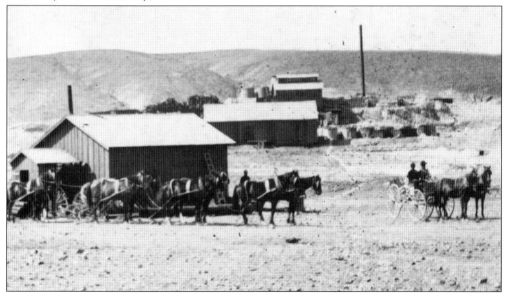

Wooden buildings can be seen in the Coleman settlement at the Harmony borax operation. Buildings such as these were a precious commodity in the desert, as every board had to be hauled in from hundreds of miles away. When camps would shut down in the desert, everything made of wood was moved to the next camp. (Courtesy Bancroft Library.)

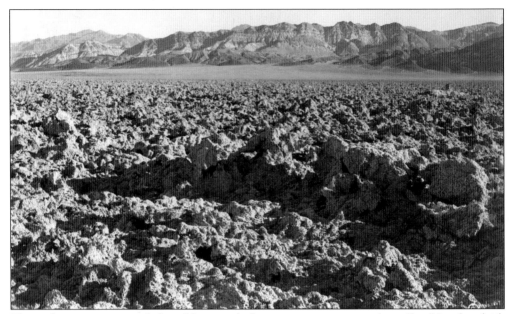

The mule teams went south from Harmony before cutting west across the valley. Here lay thick and grotesque salt beds left behind when an ancient lake dried. Over the years, the salt was carved by the wind into an extraordinarily harsh landscape. It was later called the Devil's Golf Course, when it was suggested, "Only the devil could play golf there!" The salt bed goes down at least 1,000 feet, and studies suggest it may be 9,000 feet deep. In 1883, across the Devil's Golf Course, a route had to be beaten flat using sledgehammers. That was the job of Chinese laborers.

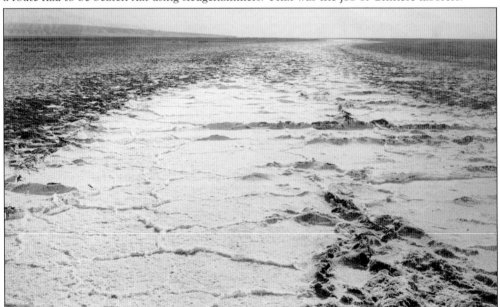

While some parts of the rugged salt beds were more difficult than others, hammering out a wagon road across the middle of Death Valley was backbreaking work. Not only did laborers have to hammer down the dry encrusted shards of salt, but they also had to contend with pockets of underlying muck and mud. Windstorms in the middle of the valley kick up tiny bullets of sand and salt, and the lack of moisture in the air makes dehydration an ever-present danger. (Author's collection.)

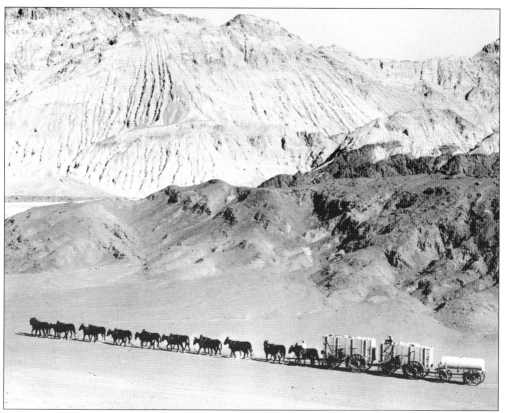

This 1930s-era reenactment photograph by Burton Frasher provides a sense of the desolation of the trip through Death Valley. The teams left early on the first day of a 10-day, 165-mile journey, often before daylight to avoid the heat. (Courtesy Frashers Fotos Collection.)

During the hottest months, all of the men, mules, wagons, and equipment were moved to the Amargosa Borax Works in the Amargosa Valley near present-day Shoshone, California. From here, the journey to Mojave also took 10 days.

None of the Death Valley mule-team drivers left any journals or memoirs. There was no need, as they were simply the truck drivers of their day. All drivers (of mule, horse, or ox teams) drove on dirt roads through undeveloped, wild regions throughout the country. It was only later, when Death Valley and The Twenty Mule Team became famous, that it mattered. Ed Stiles had driven a 12-mule team for Daunet's Eagle Borax Works in 1882 to the railhead at Daggett. After Eagle Borax failed and the Amargosa works started up, he went to work for Coleman. In later years (seen here in the 1930s), Ed claimed to be the authority on the Death Valley route and incredibly even took credit for hitching up the first 20-mule team. Nevertheless, in 1932, a request to Pacific Coast Borax for information on the route from the Automobile Club of Southern California gave Ed the chance to recall the routes and provide his considerable firsthand knowledge.

This glamorized image of a teamster was taken long after the Death Valley hauling days had passed. The rugged life of long-line freighters on the Mojave run was far from the glory that later publicity drivers would receive. Far from showy, according to one old teamster, "All the good drivers I knew had a confidence in their own abilities. They were quiet men." Coleman paid his drivers $100 to $120 a month ($2,875 today), and the swampers received $75 ($1,790).

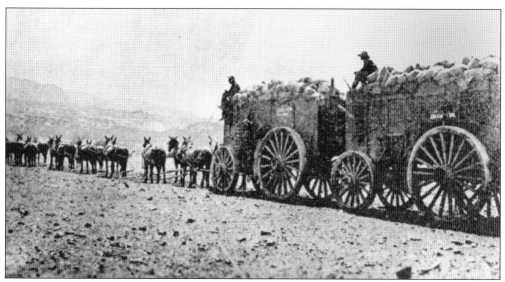

There are few images of wagons on the Death Valley-to-Mojave run, but the clue lies in whether or not the borax is sacked. At Coleman's Death Valley operation, borax was processed and sacked before being placed in the wagons. According to John Spears, "Two of these Death Valley wagons very often carried 45,000 pounds and sometimes 46,000 pounds of cargo, exclusive of water and feed for men and team, while their combined weight was but 15,600 pounds, or about one-third of their load." Note that there is no water tank attached in the Death Valley–era images. The water tanks were only taken from camps with springs to those with no springs, so they were not part of the permanent train of wagons.

According to Ed Stiles, there were two stops on the floor of Death Valley before heading up into the Panamint Mountains through Wingate Pass. They were Tule Holes and Salt Wells, where Ed said, "The water was salty but good enough for mules and tough mule drivers!"

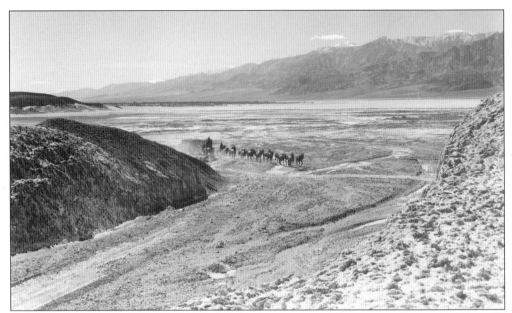

In March 1960, Borax superintendent Harry Gower wrote in a personal letter that at Salt Wells the wagons "turned west at a point 38 miles from Furnace Creek to climb up the long Wingate Wash to a 1900 foot summit where it dropped down abruptly into the south end of the Panamint Valley." Here, a reenacting team appears to be headed up a canyon, though it is not Wingate Pass and more likely Mustard Canyon near the Harmony works.

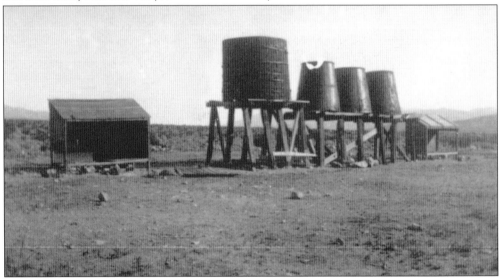

Having come down into the Panamint Valley, Lone Willow spring provided what Ed called simply "good water." The spring itself was located on the side of a hill to the west of the route. Pipes brought the water down to tanks, where it could be stored for the thirsty teams as they arrived. Here, the water wagon would be stationed and filled. It would then be taken to the next stop, which was a dry camp. From Lone Willow Springs, for 15 or so miles, the 20-mule team wagons would actually look like the familiar logo shot; however, this configuration of the wagons was not used for the entire route. (This item is reproduced by permission of the Huntington Library, San Marino, California.)

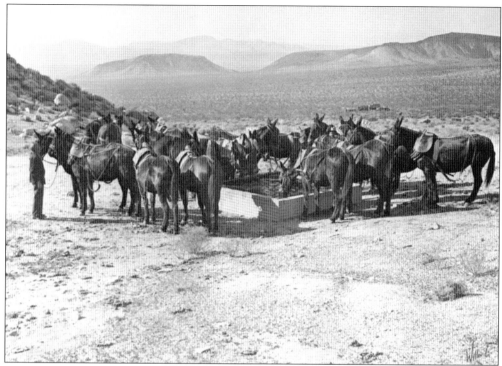

The next major stop was Granite Wells. It was at the foot of Pilot Knob, a key landmark for freighters in the region. Here, Ed said the water "was okay, if there were no dead coyotes in it!" While this photograph is of Granite Wells, it is from a later retracing of the route done by Pacific Coast Borax in 1938. The wagons can be seen far in the distance.

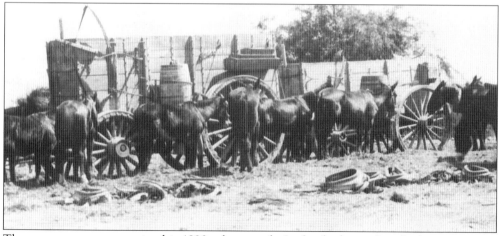

The wagons are at a stop in this 1890s photograph. It clearly shows that the harnesses were removed from the mules while resting and feeding. Reporter John Spears wrote, "The mules get their grain from boxes which are . . . secured to the wagon tongue and between the wheels. . . . They eat their hay from the ground." (Courtesy Bancroft Library.)

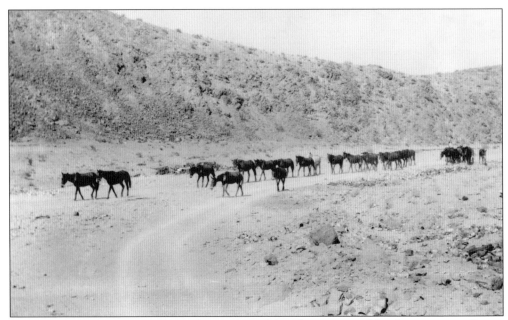

In an image from the 1890s, the mules are free of their harnesses and heading to water. Spears wrote, "Beyond feeding and watering they get no care—they curry themselves by rolling on the ground with cyclonic vigor. The cloud of dust raised is suggestive of a Death Valley sandstorm."

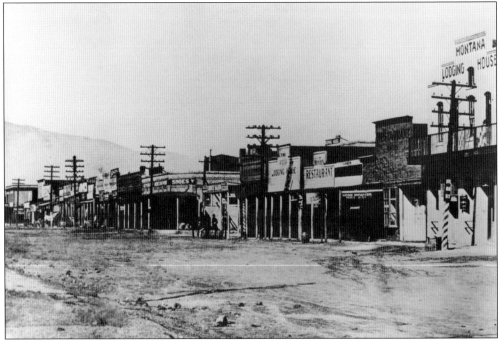

Though it is touted as the most famous route, to date no images have been found of the borax wagons arriving in Mojave from Death Valley. This image shows Mojave some years later, around 1910. According to Ed Stiles, as teams pulled into the tiny railroad town in the 1880s, they were greeted with a railcar painted with the word "Mojave." John Spears described Mojave as a "collection of shanties on as arid a part of the desert as can be found outside of Death Valley."

This c. 1912 photograph shows the Southern Pacific terminal, which was built between 1886 and 1887 and would have been present during the Death Valley-to-Mojave borax run. Fire plagued Mojave through the years, making it difficult to determine which, if any, of the buildings in the background may also have been present in the 1880s. (Courtesy Phil Serpico, Omni Publications, Vernon Sappers Collection.)

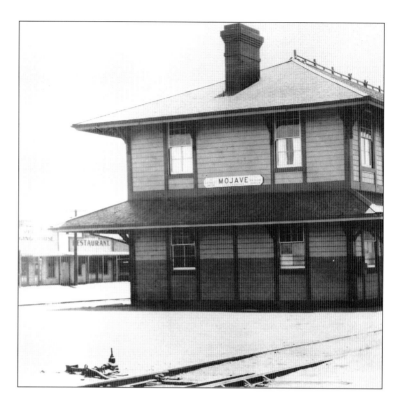

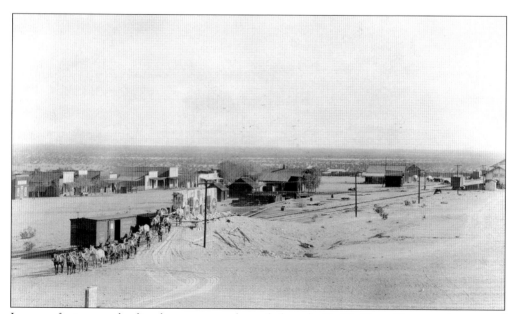

Images of a team unloading borax were only made later by Pacific Coast Borax at the town of Daggett. Since Daggett was used as a terminus before the route was cut to Mojave and then later after Death Valley shut down, it was used for borax shipments many more years longer than Mojave. This panorama of Daggett and the railroad shows the mule team unloading on the ramp.

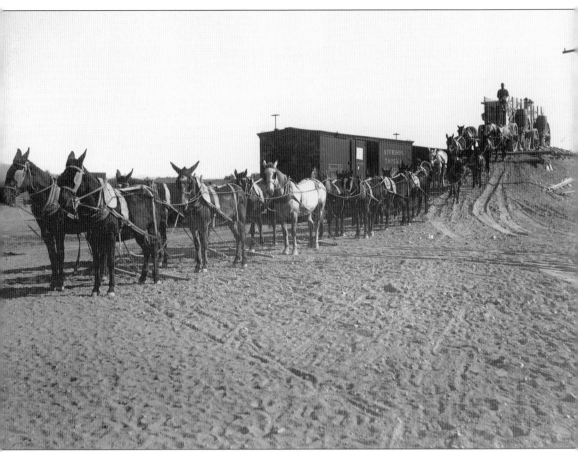

The team here can be seen in the 1890s unloading into the waiting railcar at Daggett. Drivers sat wherever they felt most comfortable and might change positions throughout the run depending on the situation. On a long, flat stretch of road the teamster may be able to sit back and relax on top of the wagon. Mules were smart enough to stop if something was not right. It was also common for the driver to ride the wheeler (the mule or horse closest to the wagon).

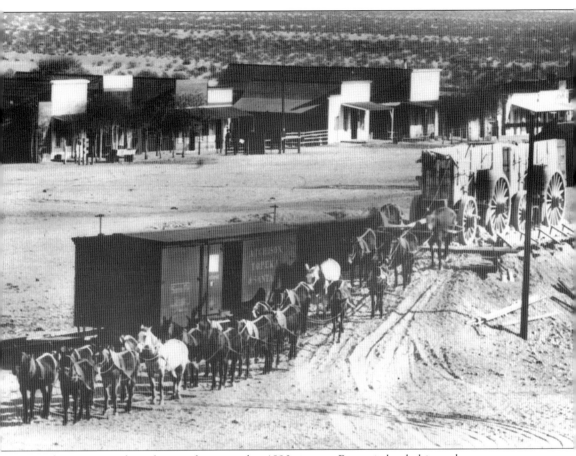

The team stands without a driver in this 1890s image. Borax is loaded into the open-top car directly behind the boxcar.

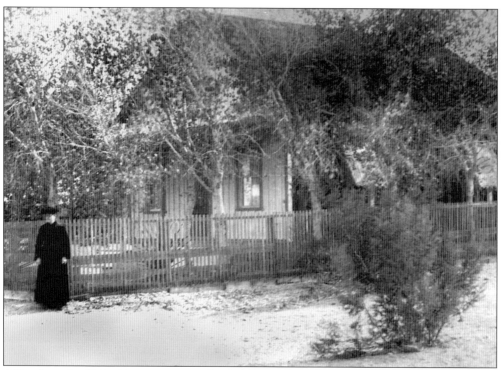

Allie, the wife of John Perry, superintendent of the Death Valley borax operation, stands outside of their home in Yermo, several miles from Daggett. Allie stayed here while he was away in Death Valley or Mojave. In a letter from 1887 she wrote, "Johnnie . . . has been having some large wagons made which are costing many thousand dollars. A man of his height is just half as high as the wagons, the wheels are about two inches taller than he is and the tires are 8 inches and they are very large in every way."

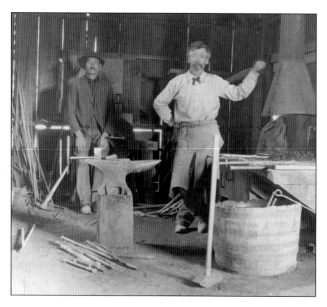

Bill Boreham was the blacksmith at the mining camp of Borate. Blacksmiths were critical to keeping the operation working by repairing wagons and iron tires. Some, like Seymour Alf of Daggett, were also instrumental in building the wagons, which was a time consuming process. As John Perry's wife stated, they were still building some of the big wagons as late as 1887. It must be remembered that it took time to season the wood for the wagons. Often times, six months to a year was necessary just to treat the wood for the wheels so there would be no additional shrinkage in the dry desert air.

The interior of the Perry home stood in stark contrast to the living conditions of miners and teamsters. Allie Perry wrote that she was so pleased to have received a Christmas gift from William Tell Coleman of "a barrel of heavy cut glassware and hand painted china and numerous other things which Mrs. Coleman selected for me."

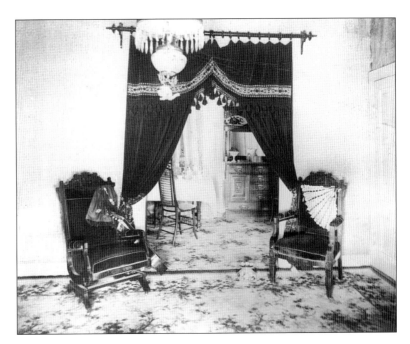

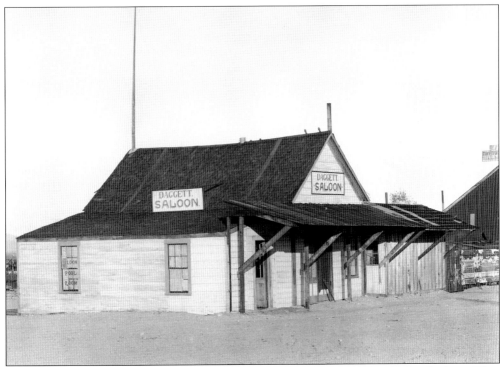

Whether in Mojave or Daggett, teamsters and swampers could be found at the local saloon. They did not have much time in Mojave during the Death Valley era as Spears writes, "Perry had the road so divided that teams went out to the valley, got loaded, and returned to Mojave on the 20th day at 3 o'clock with such a precision that it was remarkable. . . . The teamster was allowed to have the rest of the day and night to himself."

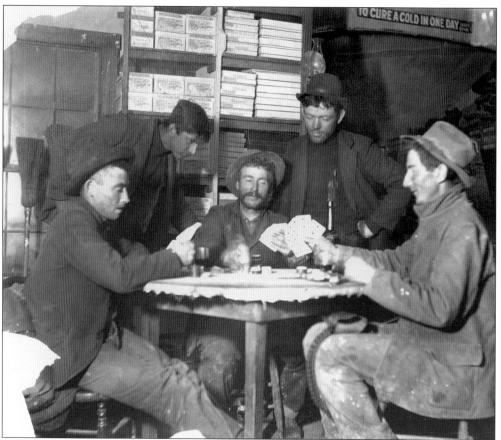

While these borax miners are playing poker, the favorite in Mojave was a game involving cards and a table called Faro. John Spears quotes John Perry as saying, "It was a good thing for us, for teamsters could go broke in one night and be ready to go out over the road in the morning."

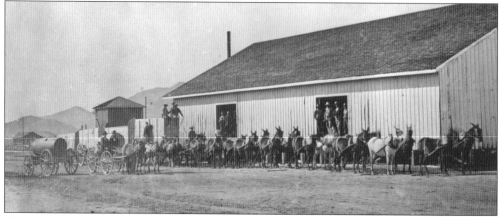

This image is possibly at a Daggett warehouse with some long-line teams. Though not borax wagons, it offers a glimpse into the busy freighting business. Author Harold Weight quoted one teamster as saying that the drivers were "hardworking, conscientious, reliable employees, otherwise the companies would not have entrusted them with $10,000 to $15,000 worth of property." (Courtesy Los Angeles Natural History Museum, Seaver Center.)

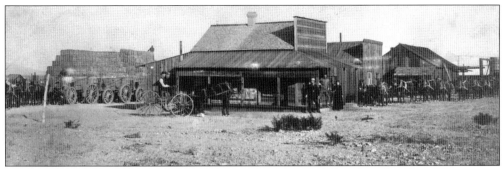

This c. 1889 image at Daggett shows borax mule teams at different stages of a trip: one team pulling in as one pulls out. The wagons stand ready to load up and go back out to the mines with hay to drop at stops along the way. (Courtesy Los Angeles County Natural History Museum, Seaver Center.)

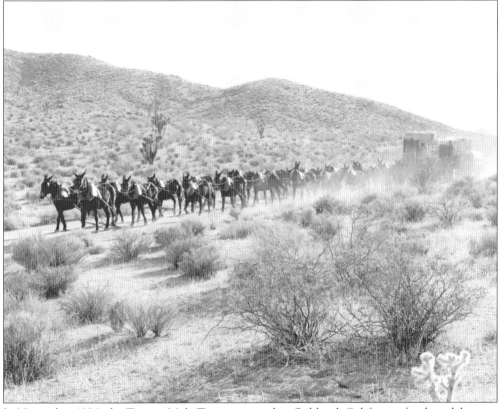

In November 1936, the Twenty Mule Team appeared in Oakland, California, for the celebration of the opening of the Bay Bridge. Since the teams were trained and the wagons were on the road, Pacific Coast Borax decided to reenact the original Mojave to Death Valley trip in December of that same year. This photograph shows that historically accurate reenactment of 1936. The team left Mojave loaded with hay and made its way to Harmony Borax in the heart of Death Valley. They are pictured here on a downgrade between Granite Wells and Lone Willow Springs heading out to Death Valley. This section of the route is now on the Naval Air Weapons Station at China Lake near Ridgecrest, California.

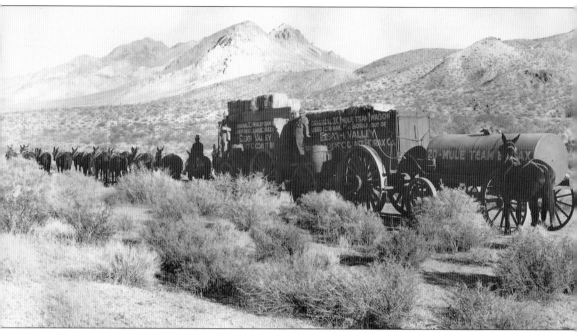

As part of the same accurate 1936 reenactment, the team is seen farther down the path towards Death Valley. The water wagon would have been used on this stretch of the route, as the tank would have been filled at Granite Wells and taken to the next camp, which was dry. An additional mule may have accompanied the team but not always. Note the advertising on the side of the wagons clearly from the later era when teams were sent out on tour to sell soap. This image was taken on the part of the route that is now on the Naval Air Weapons Station at China Lake near Ridgecrest, California.

Seven

END OF THE TRAIL

By 1888, William Coleman was shipping nearly one third of all the borax being produced in the United States from his operations at Death Valley's Harmony Borax and Amargosa Works. One thousand two hundred fifty tons a year was being produced, and by 1888 the total had reached 6,000 total tons. A single mule-team load of borax weighed about 22 tons (or 44,000 pounds) and was worth about $100,000 in today's money. Over a five-year period, the mule teams shipped nearly $30 million worth of raw borax by current standards. But a successful borax operation and distribution business was not enough. According to historian Richard Lingenfelter, Coleman placed the operation of his businesses into the hands of his son and a young man he considered as close as a son. They ambitiously pursued greater fortunes, including trying to take over the canned salmon industry and corner the raisin market. They bought into raisins when the market was high, and the prices soon dropped. Coleman lost more than $1 million. He began looking for someone to buy the Death Valley works. But when Congress removed the protective import duty on borax, Coleman could not find a buyer. On May 7, 1888, William Tell Coleman's businesses collapsed. Immediately the Harmony Borax Mining Company shut down. It was the end of Death Valley's 20-mule team days.

The man who bought all of Coleman's properties, including those in Death Valley, the Amargosa operation, and down near Barstow, California, was Francis Marion Smith. In September 1890, he consolidated all of his property and formed the Pacific Coast Borax Company. The man who had started out as a woodchopper on Columbus Marsh, Nevada, could now truly call himself the "Borax king."

Smith had much to thank Coleman for, as it would be the claims Coleman struck throughout the Death Valley and Barstow area that Smith would exploit for the next 35 years. The days of scooping borax up from salt-laden dry lake beds were over. Now, borax would be mined underground in a crystallized form called Colemanite. It was named for the man who had done so much to advance the borax industry, who had helped establish law and order during California's lawless period, and who, before he died in 1893, paid back all of his creditors.

The collapse of Coleman's empire was a shock to the country and particularly to the West Coast. The *San Francisco Daily Examiner* extolled the company as a "synonym for success, solidity and absolutely perfect business credit!" The town was in such disbelief that the newspaper declared, "Other corporations might come and go, but . . . the prize San Francisco firm must go on forever."

With a final load of borax waiting to be processed, the Harmony operation was abandoned. The fate of some of the 10 ore wagons remains a mystery. Francis Smith took two sets of wagons to work at the new operation near Barstow called Borate. Two others were sold to some freighters, and according to one account one was abandoned in the northern end of Death Valley when it got stuck in the sand on the way to Nevada.

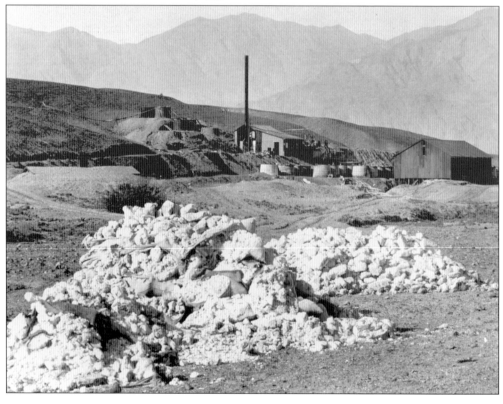

The underground mining operation at Borate in the Calico Mountains had been working since 1887. Here, in the 1890s, borax miners bring out an ore car full of borax ore called Colemanite, named for William Tell Coleman.

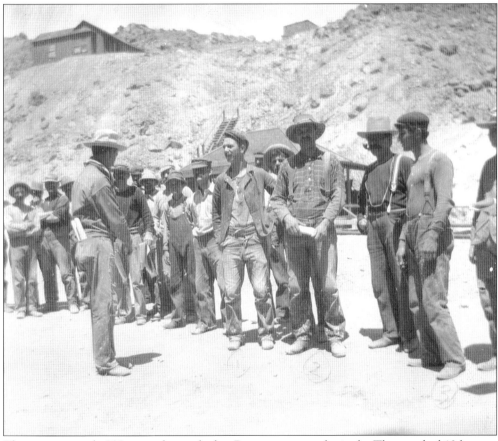

The approximately 200 men who worked at Borate were mostly single. They worked 10 hours a day, seven days a week. Once, when Francis Smith was made to feel guilty by a religious friend for not giving the workers Sunday off, he reduced the workweek by a day—and nearly started a riot. The men did not want a day off. What would they do on that god-forsaken mountain? Not only that, they lost a full day's wages. Smith told the men it was all a big misunderstanding, and work continued as usual.

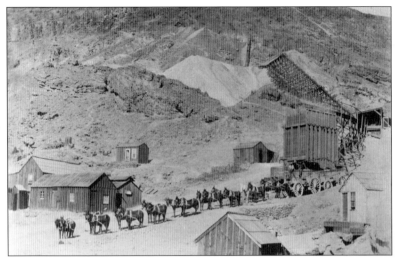

The wagons are seen having just come from the ore chutes, where they were filled with borax. At Borate, the ore was not processed on site but was brought down the mountain to the processing plant at a facility called Marion, named of course for Francis Marion Smith.

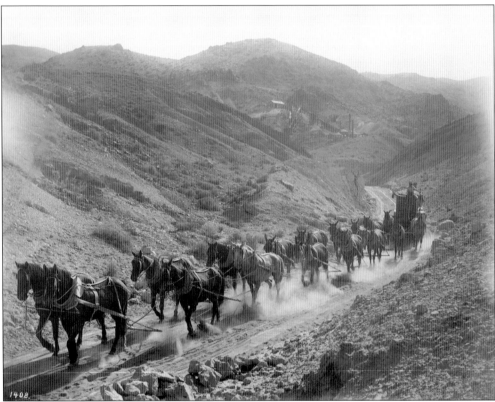

This very active shot shows a team coming down from Borate in the early 1890s with a full load. Note that there are several horses toward the front of the team. The only accounts of wrecks come from the teamsters who drove on the short Borate run to Daggett. It was only 11 miles from the mine to the railhead, but it was all but it was all uphill to the mine and all downhill going back. Writer Ruth Woodman tells the story of Al Bagley whose team "got away from him on a steep downgrade. There was a mad race, a tangle of mules and lines, a stream of colorful but futile oaths from the driver. The heavily loaded wagons overturned. Several animals were killed. Al himself was laid up for several weeks. It was the first and only trip he ever made for the company."

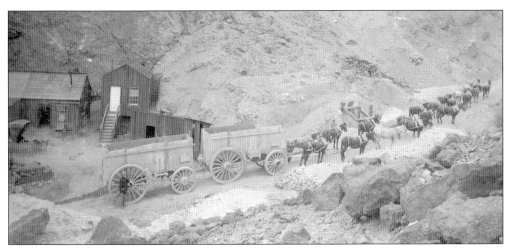

Perle Perry, the daughter of John Perry who designed Coleman's big wagons, took this early-1890s photograph. Looking closely, John Perry can be seen standing next to the wagon wheel.

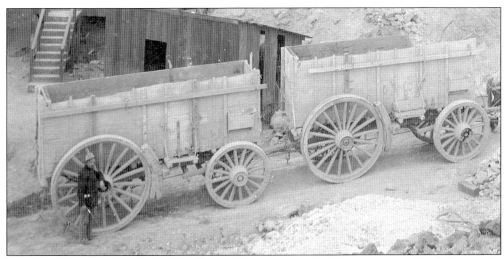

This detail of Perle Perry's photograph is important, as it offers confirmation that these wagons were used during the Death Valley operation. One of the primary differences in the borax wagons was the number of spokes on the rear wheels. There were 18 spokes on the rear wheels of Perry's giant wagons, while other wagons of the day had 16.

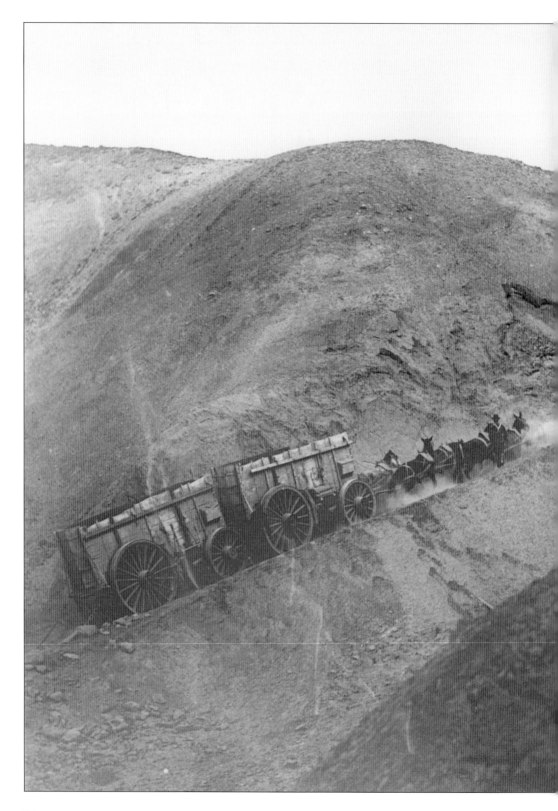

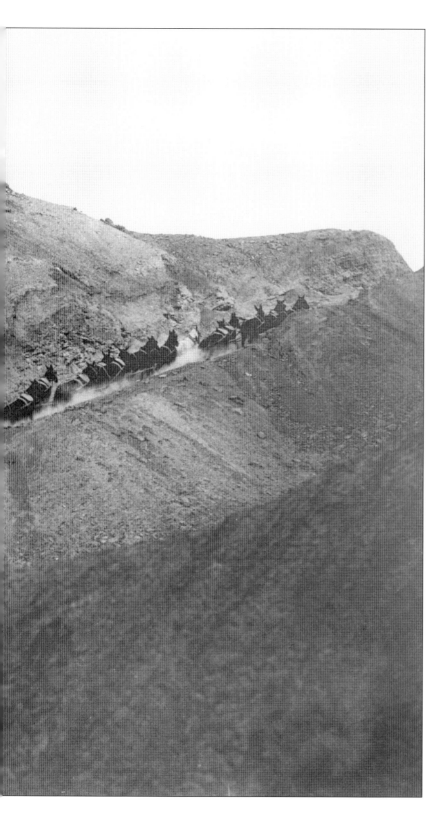

This photograph has been titled "Up the Hill at Borate." It was one of the steepest climbs on any of the mule-team routes. On steep uphill climbs, wagons with heavy loads were often unhitched and hauled up one at a time.

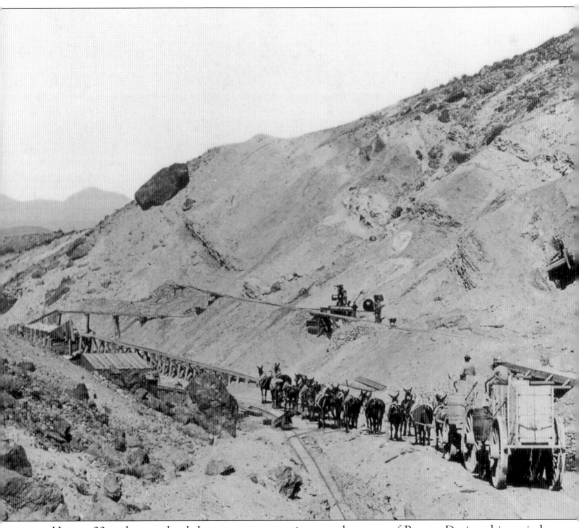

Here, a 20-mule team hauls borax past some miners at the camp of Borate. During this period, the mule teams were not only working but were also gaining notoriety.

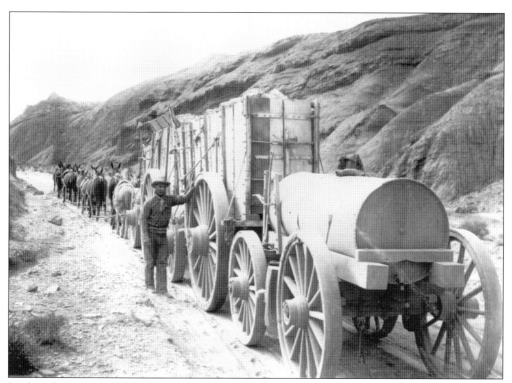

In this photograph, Ed Pitcher is the driver standing next to what is one of the original Death Valley wagons. Note the sideboards on top of the front wagon to hold more ore. The boards are typical of wagons built for the Borate operation by Daggett blacksmith Seymour Alf. The water wagon would have been taken down to Daggett, filled up, and brought back to Camp Rock, which was a dry stop on the route.

A team is hauling ore down from the mines in the early 1890s on its way to the one stop on the route, Camp Rock. (Courtesy Los Angeles County Natural History Museum, Seaver Center.)

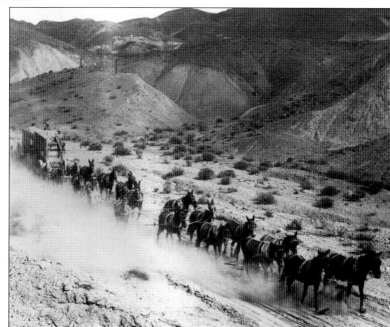

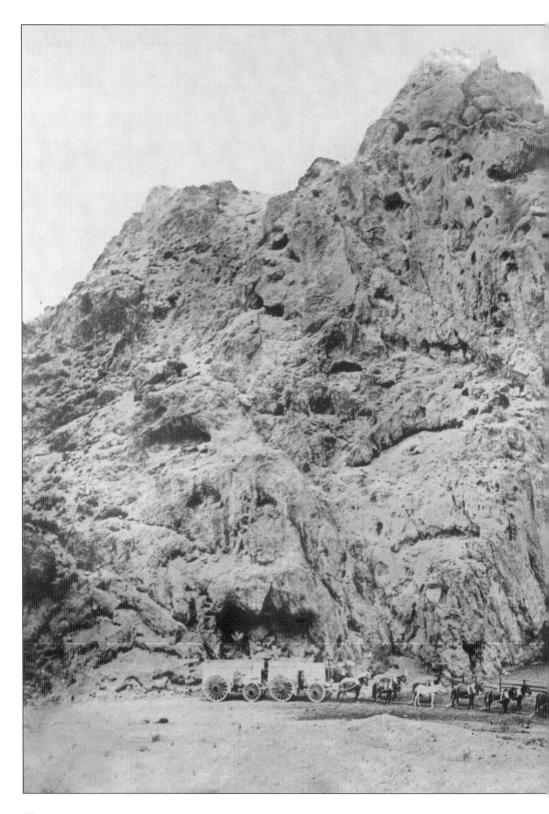

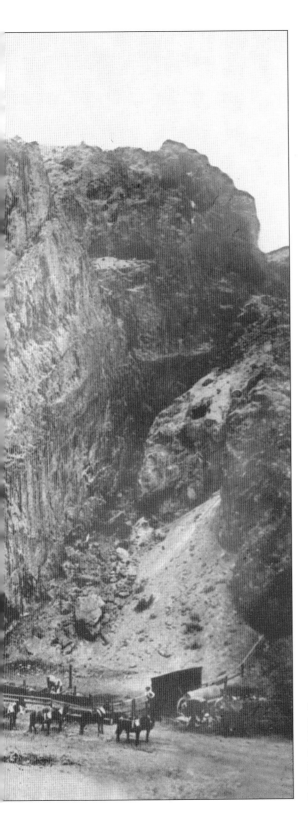

Camp Rock was the primary stopping point for the mule teams, as it was nearly halfway to Daggett. The entire run was only 11 miles at its longest. The teams took a day and a half to get to the mines and day and a half to return for a three-day trip.

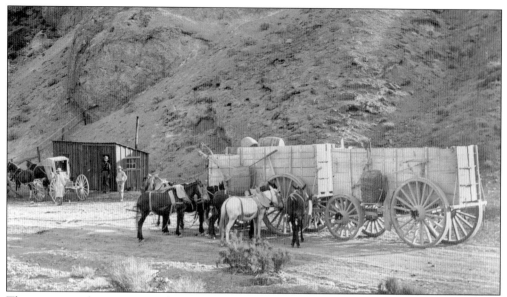

The wagons and team are seen here at Camp Rock. The wagons are positioned to go back down the mountain to Daggett. Note that the mules have been unhitched from the wagons and may be feeding next to them. In many of the photographs from the Borate era, a white mule is present in the team. (Nevada Historical Society.)

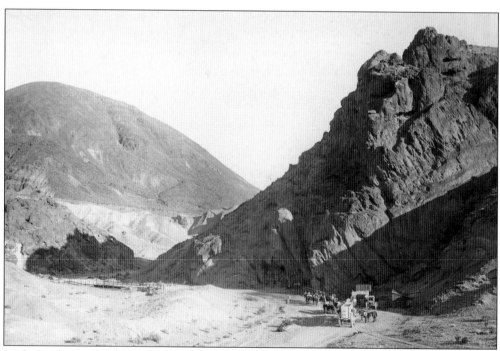

In this wide view of Camp Rock, the wagons appear to be heading back down the mountain; however, note they are not full of borax. Also visible next to the mountain are two water wagons. To the left of the wagons is a corral. This run of the wagons up to the mines and back may have been staged entirely for Frederick Monsen's camera.

As in the Death Valley era, only two men ran a team. The swamper rode in the rear wagon and operated the brake. Author John Spears wrote, "If the brake holds, all is well, but now and then a brake-block gives way, then a race with death begins. With yells and curses, the long team is started in a gallop, an effort is made to swing them around the mountainside, a curve is reached, an animal falls or a wheel strikes a rock or rut and with thunderous crash over go the great wagons!"

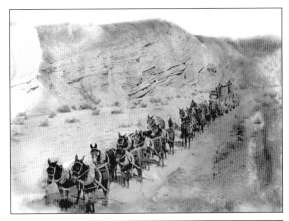

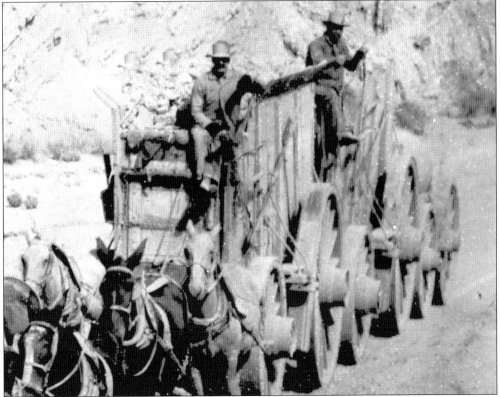

On the long Death Valley run, Spears wrote, "It was necessary whenever a team came in to inquire of each man separately whether he was perfectly satisfied with the other. If the least ill will was displayed by one toward the other, a new swamper was provided, lest a fight follow on the desert and one kill the other!" And that only happened on the Death Valley run when an impatient swamper named Wassum killed teamster Al Bryson at the stop at Saratoga Springs. Apparently, Bryson took too long to open a can of peaches and a fight broke out. Wassum struck Bryson with a shovel, killing him instantly. Wassum buried the body and rode a mule back to town. When he arrived without his teamster, he was arrested. No one wanted to go to Death Valley and investigate, so Wassum was acquitted. Pictured here on the short Borate run is teamster Frank Tilton, who never drove in Death Valley. Note that the horses are used as wheelers next to the wagon. The Death Valley operation used either horses or mules as wheelers.

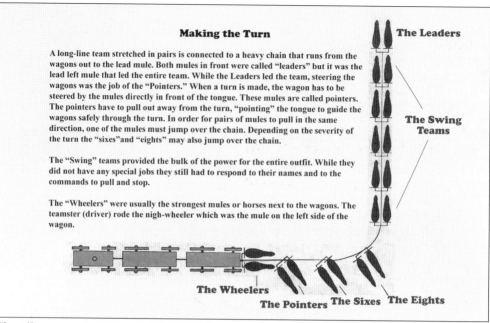

Making the Turn

A long-line team stretched in pairs is connected to a heavy chain that runs from the wagons out to the lead mule. Both mules in front were called "leaders" but it was the lead left mule that led the entire team. While the Leaders led the team, steering the wagons was the job of the "Pointers." When a turn is made, the wagon has to be steered by the mules directly in front of the tongue. These mules are called pointers. The pointers have to pull out away from the turn, "pointing" the tongue to guide the wagons safely through the turn. In order for pairs of mules to pull in the same direction, one of the mules must jump over the chain. Depending on the severity of the turn the "sixes" and "eights" may also jump over the chain.

The "Swing" teams provided the bulk of the power for the entire outfit. While they did not have any special jobs they still had to respond to their names and to the commands to pull and stop.

The "Wheelers" were usually the strongest mules or horses next to the wagons. The teamster (driver) rode the nigh-wheeler which was the mule on the left side of the wagon.

The Leaders

The Swing Teams

The Wheelers

The Pointers The Sixes The Eights

This illustration from a pamphlet published by US Borax shows how a turn is made and the primary jobs of the mules.

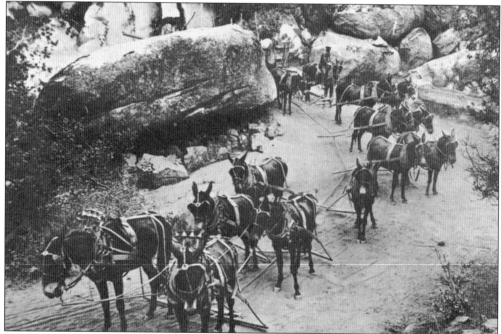

This image is not of the borax operation at all, but it is from the period illustrating a 14-mule team with three sets of mules over the chain. Note that they are pulling in nearly the opposite direction as the rest of the team. Once the wagons are brought out safely around the rock, the mules will then jump back over the chain and resume their position in a straight line. The mules are trained to jump on voice command, and each one knows their name.

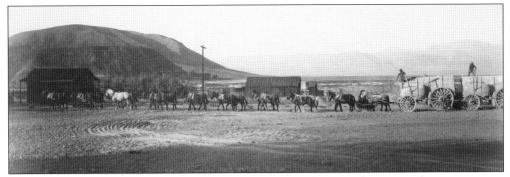

The teams arrived in Daggett to unload the ore and to pick up supplies. Here, the swamper can clearly be seen applying the brake on the rear wagon. The teamster is standing on the wagon, operating the brake with his left hand and steering a team by holding the jerk-line in his right.

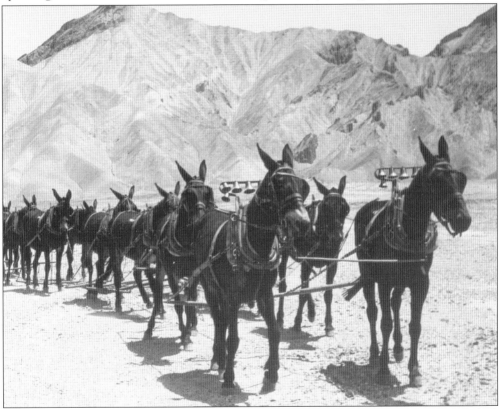

A detail of the two lead mules from a later reenactment team clearly shows how the team worked. A bar called a "jockey stick" (clearly visible here) was placed between the two lead mules. The jocky stick would signal to the right-side mule (viewing, on the left) whether to go left or right. It all depended on what direction the lead mule (on the right) received from the teamster. The jerk-line stretched from the teamster to the lead left mule. A steady pull on the line took the lead mule to the left, gently guiding the rest of the team in that direction. A series of jerks to the lead (or line) mule would signal the lead mule to go right. The turn of the lead mule to the right bumped the jockey stick, which in turn bumped the lead right mule, taking the entire team to the right. The teamster may use the command "gee" for a right turn and "haw" for the left, but there are no hard and fast rules.

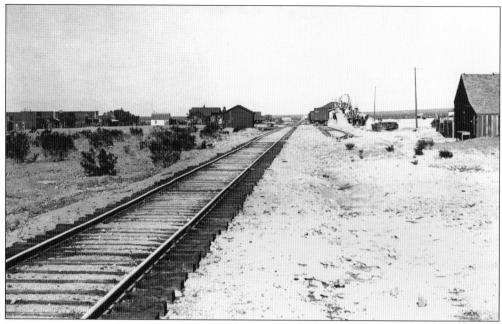

Far in the distance, down the railroad tracks at Daggett, a mule team is arriving to unload borax ore.

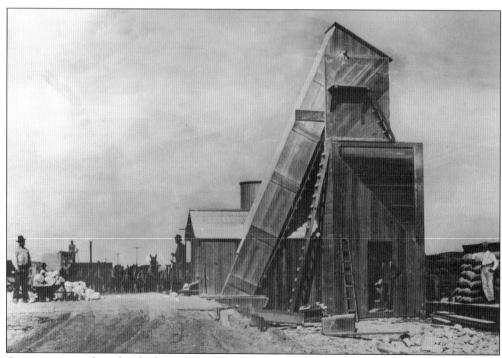

A team approaches the dock at the railhead at Daggett. Borax can be seen to the left in a wheelbarrow. (Courtesy Los Angeles County Natural History Museum, Seaver History Center.)

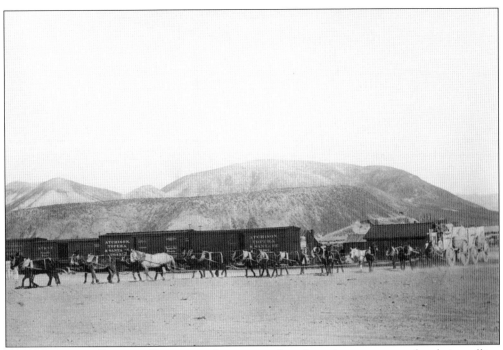

Here, a team is pulling into Daggett, and it appears that the pointers are over the chain pulling towards the camera so as to take the wagons out to make a turn to the wagon's right.

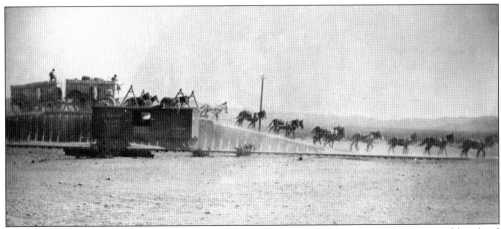

This dramatic view shows a mule team on the ramp next to the railcar, where it would unload the borax.

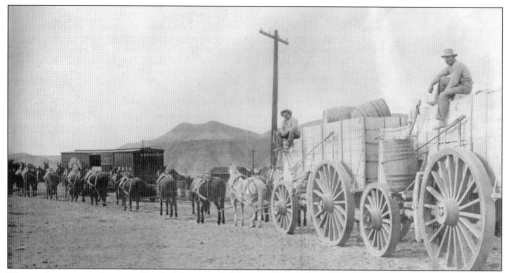

Here, the wagons have unloaded borax and have reloaded with supplies to take back up to the mine at Borate.

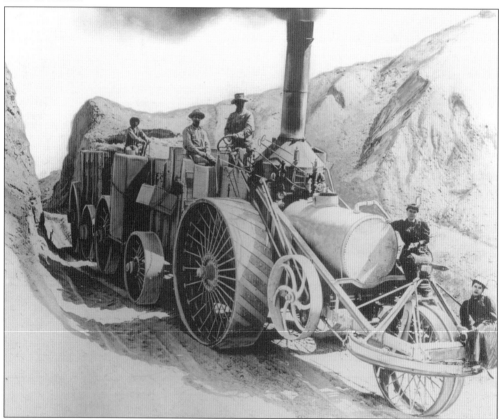

In 1894, Francis Smith purchased a steam-traction engine from the Best Tractor Company (forerunner of today's Caterpillar, Inc.), along with two steel-wheeled wagons seen in the photograph. He nicknamed the tractor "Old Dinah" and tried the new outfit on the Borate-to-Daggett run. The crew poses for the camera with a couple of lovely ladies aboard.

While the tractor looked impressive, it could not handle the harsh desert. It was not long before Old Dinah sputtered to a complete stop in the desert sand. More often than not, she had to be pulled to the repair shop by the mules. Finally, Smith tired of her and gave her to a businessman in Nevada, who managed to blow out her engine on a pass in Death Valley. In the 1920s, Pacific Coast Borax retrieved her to become a tourist attraction in front of Furnace Creek Ranch. Here, in the 1930s, photographer Burton Frasher manages to catch ladies atop the old tractor, though it is clearly a different generation from the previous photograph. Today, Old Dinah can be seen at the entrance to Furnace Creek Ranch in Death Valley. (Courtesy Frashers Fotos Collection.)

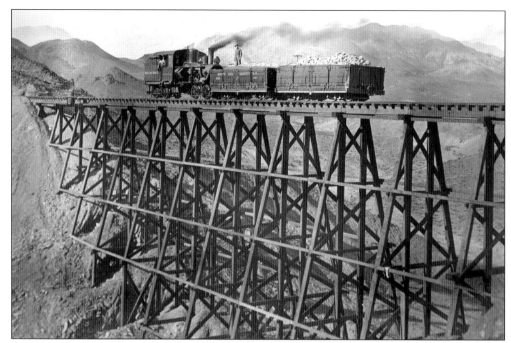

Smith was determined to replace the mules, however, and in 1898 he built an eight-mile narrow-gauge line he called the Borate-Daggett Railroad. The days of hauling borax by mule team were over.

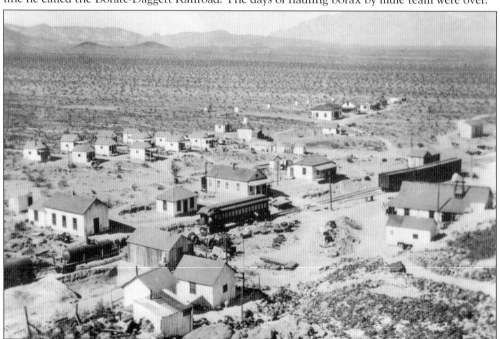

By 1906, the ore at Borate had played out, and another claim struck by Coleman was being exploited. Pacific Coast Borax went back to Death Valley to mine at the Lila C., believed to be named for Coleman's daughter. The company moved everything from Borate to the Lila C. to set up its mining operation. The town site was named Ryan after Smith's trusted friend and employee John Ryan.

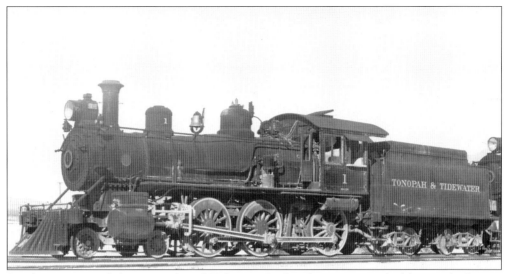

Smith incorporated the Tonopah and Tidewater Railroad Company to build a standard-gauge line (track width of four feet, eight and a half inches) from the Tidewater at San Diego to the booming mines of Tonopah—it never made it to either. It was only a short, 200-mile run from Ludlow, California to Beatty, Nevada.

The railroad brought civilization to the desert and a faster means of transportation than buckboard or wagons. Here, passengers and crew stop for a photograph near present-day Shoshone, California. Construction of the line, however, would take longer than expected, and there were many delays. The mine at the Lila C. was producing, and ore was ready for shipment. A dilemma was facing the company as to how to get the ore to the railroad.

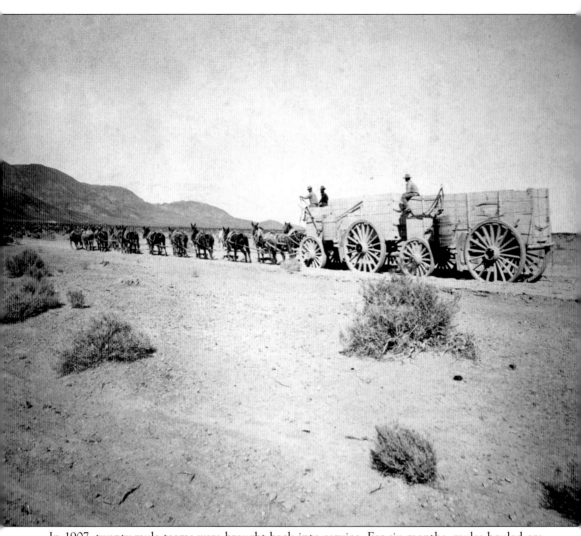

In 1907, twenty-mule teams were brought back into service. For six months, mules hauled ore from the mine at the Lila C. to the approaching rail line. Then, in August 1907, a railroad spur connected from the mine to Death Valley Junction to meet the Tonopah and Tidewater Railroad. This image of a 20-mule team from the Lila C. is the last photograph of such a team hauling borax. By the count of the spokes on their wheels—at 18—this is one of the original wagons built by Coleman.

Eight

SELLING SOAP

After Francis Smith incorporated Pacific Coast Borax in 1890, he was faced with a dilemma: as the largest supplier of borax in the world, he must also increase the demand for his product. He would do that by finding more uses for borax, creative packaging, and marketing.

In 1891, Smith's New York sales manager, Joseph Mather, was pondering the matter when his son Stephen suggested an idea. After listening to his father and Smith reminisce about mule skinners and big wagons, he thought they should call the product 20 Mule Team Borax. In a letter to Stephen Mather, Smith resisted, "I cannot say I like the idea of the 'mule team' brand of borax. My name and that of the company should be in the foreground." After all, that is what his friend Charles Pfizer did. But young Mather persisted, noting the popularity of Wild West shows where stagecoach robberies and shoot-outs were reenacted. Fortunately for Smith, his company had a strong connection to one of the wildest places in the West: Death Valley. By 1891, its reputation was growing. The pioneers who had named it were now telling their stories. Mather also knew the best feature writer for the *New York Sun*, John Randolph Spears. Spears had traveled the world writing stories and agreed to come to the remote desert operations at Borate.

Smith finally agreed to the brand name and to pay for Spears's trip to the desert; however, he would put no money into marketing. That would be up to the creative genius of Stephen Mather.

With Smith's blessing and financing, Joseph Mather sent Spears to Borate to watch the mules in action. No matter that the Death Valley operation was long shut down, Spears would write dramatic stories that would be published as a series in the *New York Sun* and then as a book in 1892 by Rand McNally called *Illustrated Sketches of Death Valley and Other Borax Deserts of the Pacific Coast*. It is not a catchy title, but it was the first book on Death Valley and introduced "The Twenty Mule Team" to the public. The line between advertising and real history had officially been blurred, and the legend of The Twenty Mule Team was born.

In this 1890 photograph, Stephen Mather and his father, Joseph, were both working for Francis Smith's Pacific Coast Borax Company. Stephen believed the story of Death Valley and the mule teams was key to branding, marketing, and promoting borax.

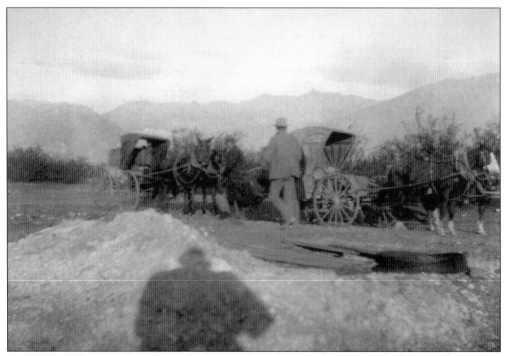

Spears not only wrote but also took photographs of his 1891 trip. His shadow can be seen in photograph at one of their stops in Death Valley. Spears's reputation as an outstanding feature writer for the *New York Sun* made him Stephen Mather's first choice to go to Death Valley and write the borax story. (This item is reproduced by permission of the Huntington Library, San Marino, California.)

The result of Spears's writings was the first book about Death Valley. Its romantic and dramatic portrayal of the mule team freighting through the dangerous desert branded the borax team as *the* Twenty Mule Team. While 20-mule teams were used throughout the West from as early as the 1860s, it was Stephen Mather's genius and Spears's writing that turned a 20-mule team into *the* Twenty Mule Team. It is a tribute to the early use of media and marketing that they could create an iconic brand from a common form of transportation. (Author's collection.)

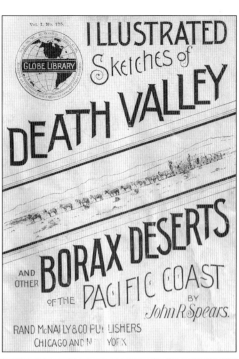

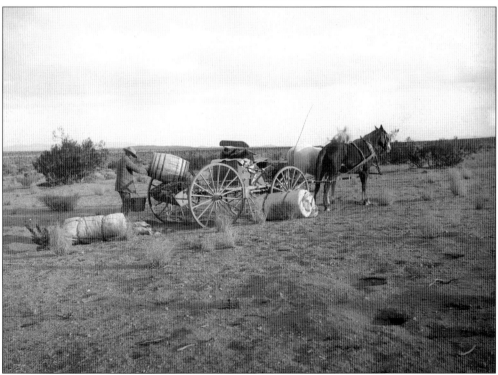

Stephen Mather was not content with just the book—he needed photographs. He convinced Smith to hire Frederick Monsen. Monsen was well known for his western photography, particularly of Native Americans. In 1892, he began traveling the desert. Here, he unloads his photography equipment.

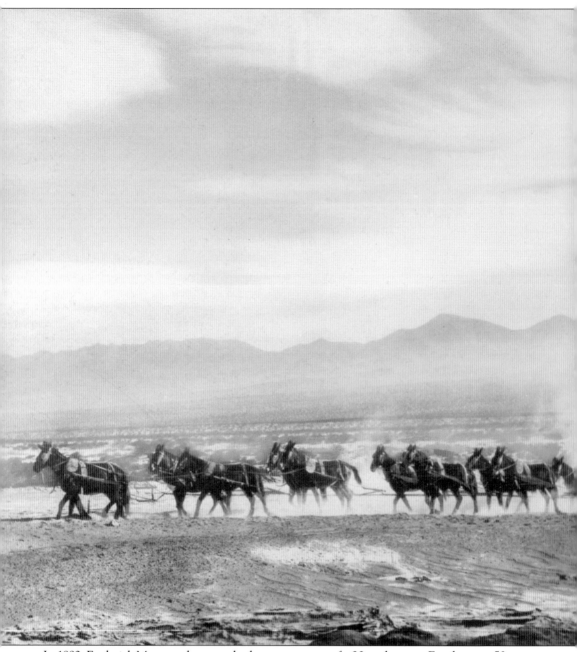

In 1892, Frederick Monsen photographed a reenactment of a 20-mule team. For the next 50 years, this image was the trademark and logo of Pacific Coast Borax. It was labeled, "The Twenty Mule

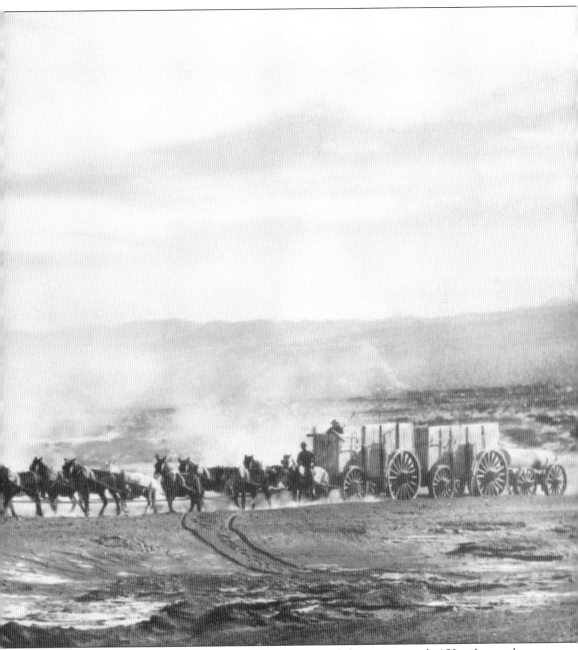

Team Hauling Borax Out of Death Valley." Never mind that it was nearly 150 miles southwest of Death Valley on Coyote Lake near the railroad town of Daggett, as the purpose of the image was to sell soap.

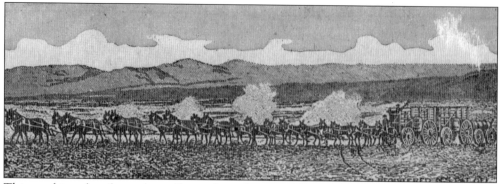

This graphic, taken from a box of borax from the 1890s, shows the use of Monsen's photograph in creating the trademark. Note the tracks coming toward the camera; they can also be seen on page 105 and are likely those of repeated repositioning of the mule team for the camera. (Author's collection.)

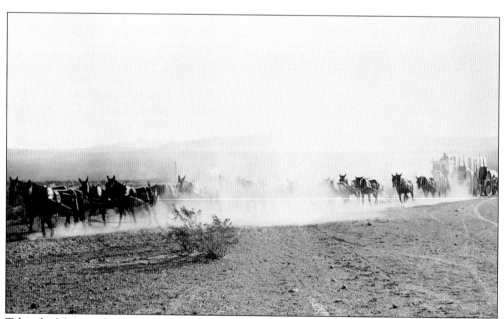

Taken by Monsen during the 1892 reenactment on Coyote Lake, this image was rejected as the trademark but saved for its dramatic effect.

Frederick Monsen became so intrigued with Death Valley, he created a "moving picture show" (a lantern slide show) and took it on the road. On December 9, 1893, the president of Pacific Coast Borax, Francis M. Smith, attended Monsen's presentation. "The lecture was exceedingly well prepared and interesting," Smith wrote, "I think your assistant failed to focus well, but the photographs were fine, notably the colored views. I do not see why you may not achieve success."

Through Death Valley

A SUPERBLY ILLUSTRATED LECTURE

BY

FREDERICK I. MONSEN

(The Incidents of an Exploration 430 feet below Sea level)

* * * Mr. Monsen has made a reputation by penetrating into the least known and most mysterious region in the United States, viz: Death Valley. The object of this exploration and a two years' experience throughout the deserts of the Southwest was to secure ample and reliable information concerning this wonderful sink and the surrounding deserts, and to thoroughly illustrate, by means of the camera and brush, the many natural attractions of this strange and weird land. Mr. Monsen has embodied his researches in a series of intensely interesting lectures, and illustrates them by brilliant stereoption views—the only pictures of this strange land ever exhibited.—*Pasadena Star.*

To-Morrow Another House and Home Day.

ALL TO-DAY'S HOUSES AND ROOMS ADS. WILL GO FREE IN THE EVENING WORLD.

THE WORLD.

THE WORLD: SUNDAY, SEPTEMBER 16, 1894.

THE HORRORS OF DEATH VALLEY.

The Reptile-Inhabited, Sun-Baked, Waterless Desert in California--The Loneliest, Hottest and Most Desolate Spot in This Country.

The Valley of Death, Inyo County, California, is the loneliest, the hottest, the most deadly and dangerous spot in the United States. It is a pit of horrors—the haunt of all that is grim and ghoulish. Such animal and reptile life as infests this pest-hole is of ghastly shape, rancorous nature and diabolically ugly.

corpses are scattered over the burning plain, he rarely, if ever, ventures down to the fatal torrid level. Some few specimens of animal life contrive to exist in this desert, but they are of unique species and essentially freaks. As if in sympathy with the uncanny nature of the place, they have impish habits and distorted anatomies, such as Ingoldsby attributed to the fantastical

top of a load of borax, fell over and expired. He was so parched that his head cracked open over the top."

A Frenchman named Isidore Daunet had a terrible experience in and around the valley. In 1880 he, with six others, attempted to cross, bound for Arizona. He was a strong, vigorous, healthy man, and scouted the idea of danger in so narrow a strip of land. The party started, and before they realized their condition their water was gone. Half wild with suffering they cut the throats of their pack animals and drank the spurting blood, as tigers might have done. Daunet and the strongest of the band escaped with life. Three perished. Some time afterwards the Frenchman tied up his head in a white handkerchief, sat down facing a mirror and put a bullet in his brain.

The Indians and Piutes who dwell in the woods at the border of Death Valley are restricted to a peculiar diet. Their staple food is lizard flesh. One of these reptiles, called the "Chuckwaila" by the whites and the "Chahwalla" by the Indians, is large enough to weigh three pounds when dressed. The Indians place them as caught between two hot rocks to roast. The whites dress them and broil them on the coals of a sagebrush

Fortunately for Smith and Pacific Coast Borax, Death Valley's reputation as the last holdout of the Wild West continued to grow. *The New York World* published an extraordinary article in 1894 calling it the "pit of horrors" and the "haunt of all that is grim and ghoulish." (This item is reproduced by permission of the Huntington Library, San Marino, California.)

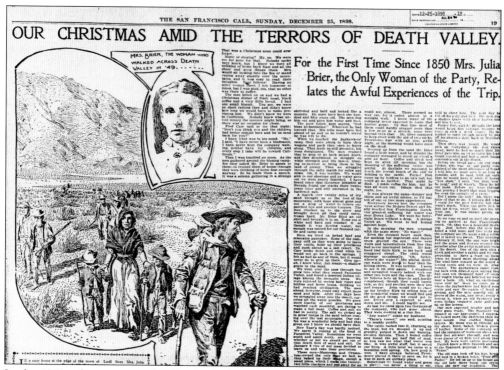

In the 1890s, the pioneers of 1849 who had struggled through and named Death Valley began telling their stories. William Lewis Manly published his classic *Death Valley in '49*, and others like Juliet Brier would tell their stories to newspapers and magazines. The publicity about Death Valley was good for the borax business.

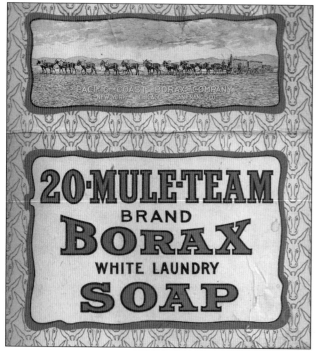

This is the cover of a box containing packages of borax bar soap from the early 1900s. Note that the packaging is actually comprised of the prominent trademark image and tiny mule faces. (Author's collection.)

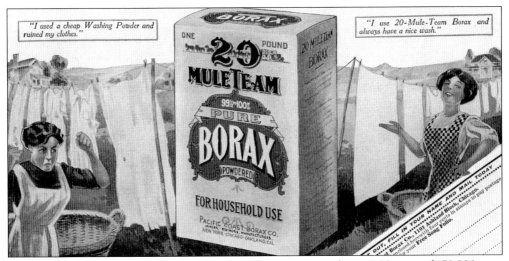

In 1903, Francis Smith was determined to put "borax in every house." He spent $150,000 on a national advertising campaign, which today would be more than $3.5 million. Pitting the non-borax-using women against the borax-using ones was a popular tactic. Note the ornate packaging for borax about 1903. (Author's collection.)

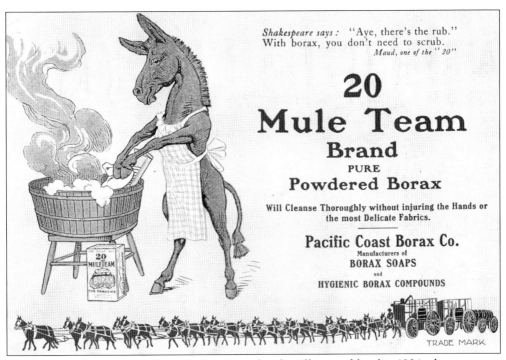

The company became creative with their use of mules, illustrated by this 1904 advertisement. (Author's collection.)

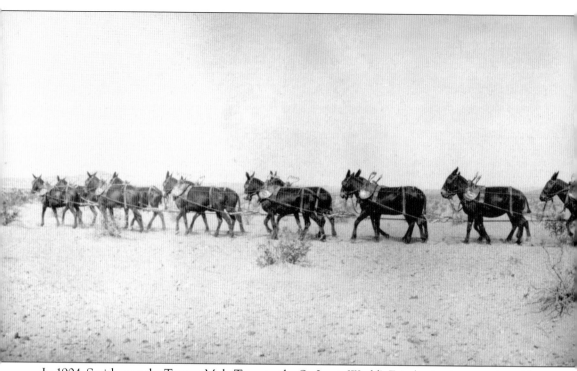

In 1904, Smith sent the Twenty Mule Team to the St. Louis World's Fair, beginning a nationwide tour. Matching mules were bought for $300 apiece. Here, the team is seen practicing on a dry lake bed at Coyote Lake for its appearance at the fair. Note that every mule has bells; normally, bells would only be on the lead mules. They were used as a signal to other drivers and also provided a

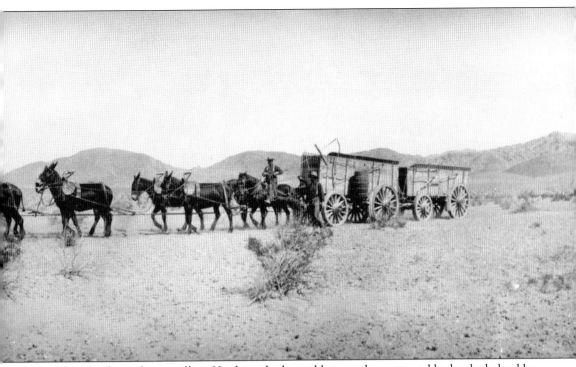

cadence for the mules to pull to. If a driver had a problem on the route and had to be helped by another teamster, he surrendered his bells. The phrase "I'll be there with bells on" meant that a driver would arrive without any mishaps and thus did not have to give up his bells. (Courtesy Tom Nelson, whose grandfather Walter is pictured here driving the team.)

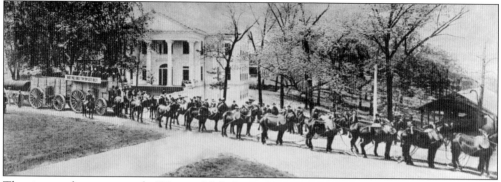

The sign on the wagon reads, "Twenty Mule Borax Team From Death Valley." The *St. Louis Post Dispatch* reported, "Daily, with a jingle of bells, the strangest caravan within the walls of the World's Fair sets out for a tour." Seats were placed on the wagons to take visitors on free rides around the fairgrounds.

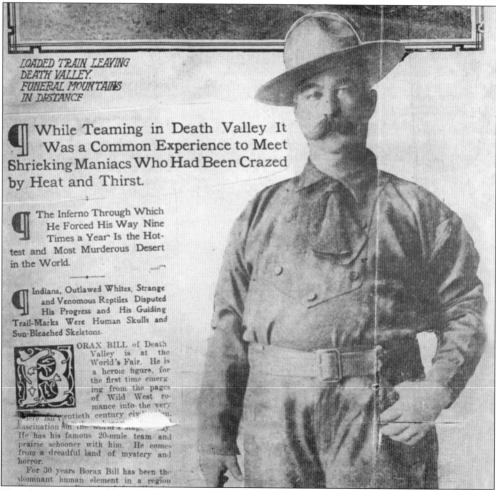

LOADED TRAIN LEAVING
DEATH VALLEY.
FUNERAL MOUNTAINS
IN DISTANCE

While Teaming in Death Valley It Was a Common Experience to Meet Shrieking Maniacs Who Had Been Crazed by Heat and Thirst.

The Inferno Through Which He Forced His Way Nine Times a Year Is the Hottest and Most Murderous Desert in the World.

Indians, Outlawed Whites, Strange and Venomous Reptiles Disputed His Progress and His Guiding Trail-Marks Were Human Skulls and Sun-Bleached Skeletons.

BORAX BILL of Death Valley is at the World's Fair. He is a heroic figure, for the first time emerging from the pages of Wild West romance into the very twentieth century civilization. There is a fascination on the world's stage today. He has his famous 20-mule team and prairie schooner with him. He comes from a dreadful land of mystery and horror.

For 30 years Borax Bill has been the dominant human element in a region

The driver was an old Nevada teamster named Bill Parkinson. He had never driven in Death Valley, but that did not matter to the *St. Louis Post Dispatch*. He was also an egomaniac who insisted that he be waited on by a group of swampers. He was soon replaced.

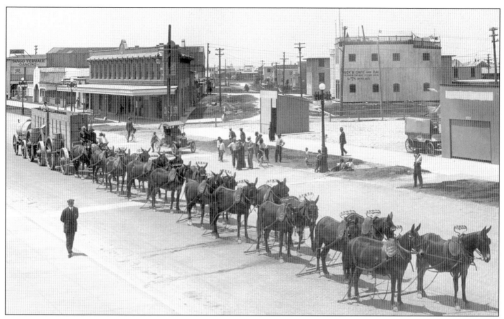

After the World's Fair, a team was sent on tour around the country. America was introduced to the Twenty Mule Team of Death Valley. This appears to be in St. Louis shortly after the fair.

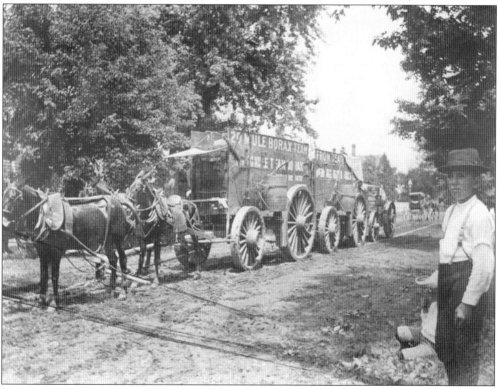

The tour lasted two years, and in 1906 Francis Smith wrote, "As soon as it reached New York . . . I thought it best to take it off the road." It had been quite expensive. The mules were sold and the wagons sent back to the railroad offices at Ludlow, California.

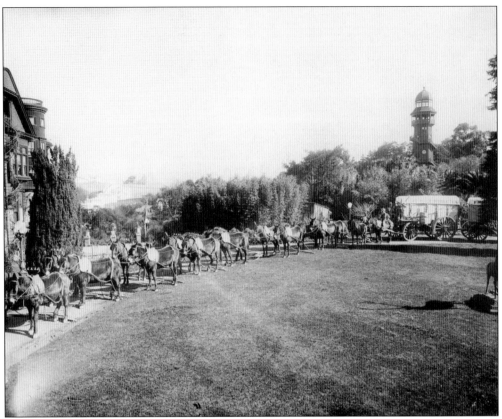

In 1916, the team went on tour again, but Francis Smith was no longer with the company. Much like Coleman before him, he overextended his investments and in 1913 went bankrupt. He was forced to leave the company he created. As a courtesy, the team stopped at Smith's estate, called Arbor Villa, in Oakland, California.

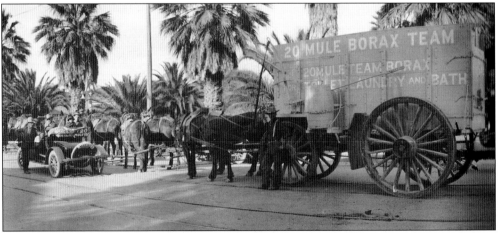

On tour, someone dressed as a swamper would extol the virtues of borax proclaiming, "These wagons rolled through Death Valley never having a breakdown. If you use 20 Mule Team Borax, your laundry will never have a breakdown either!" Here, a team is on tour in Southern California. (Author's collection.)

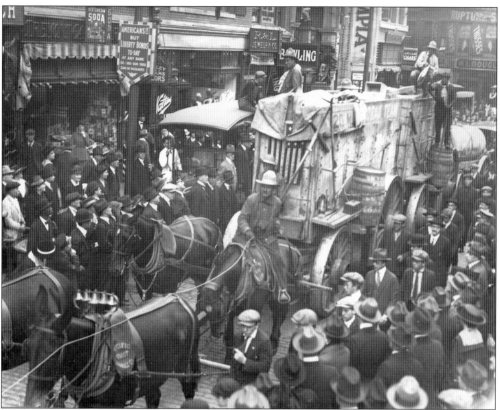

Frank Wilson was another Nevada teamster. Note the jerk-line in Wilson's hand, which was made of round leather for the tour, not rope as the original jerk-lines. The team consisted of 18 black mules and two black horses for wheelers. (Author's collection.)

In Los Angeles, the team makes a turn. The pointers can be seen across the chain pulling the wagons out to avoid the crowd of people standing near the cars. The mules were not used to pavement and would often slip during the early days of the tour until they figured it out.

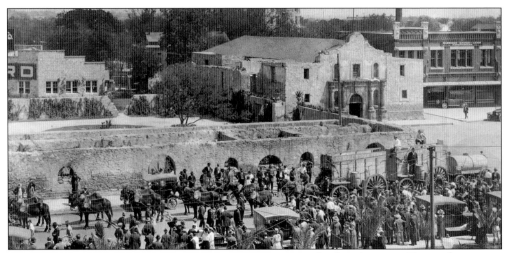

In San Antonio, Texas, the team stopped at the Alamo. Note the man on the wagon giving the borax lecture.

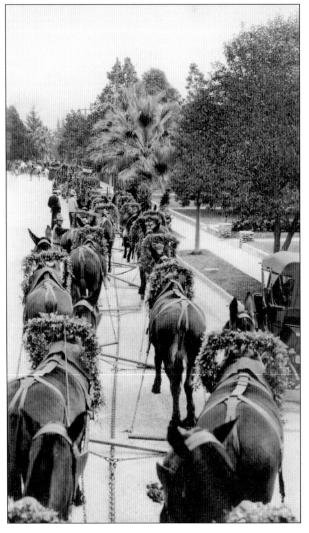

On January 1, 1917, the Twenty Mule Team made its first appearance in the Pasadena Tournament of Roses Parade. It appeared again 82 years later on January 1, 1999.

Nine

MEDIA STARS

In 1917, Pacific Coast Borax was mining in Death Valley. It had been there since 1906, when it opened the Lila C. claim and set up the town of Ryan. In 1912, the company moved its operation to the mountains above Death Valley and set up New Ryan. Though there was nothing romantic about the realities of harsh, desert, underground mining, the public was enamored with the Twenty Mule Team. Its popularity rose as the Wild West became even more prominent on the radio and in the movies.

In 1930, the advertising agency for Pacific Coast Borax, McCann-Erickson, suggested that it produce a radio program. Writer Ruth Woodman was hired to go out to Death Valley and gather tales that could be produced into a weekly program. Each week, the program began with a bugle call and the sounds of wheels and snorting mules would be brought into living rooms around the nation. The radio program *Death Valley Days* was making Death Valley and the Twenty Mule Team household names. Not only that, the public could actually go to the grocery store and purchase a box of 20 Mule Team Borax, bringing the iconic image and its Wild West aura right into their own homes. And on top of all that, if someone wanted to go to Death Valley and visit, he or she could stay at one of the four accommodations run by Pacific Coast Borax.

The Twenty Mule Team and its story was also beginning to attract attention from Hollywood. In 1940, MGM produced *20 Mule Team*, starring Wallace Beery. To publicize the film, the team was sent on a 40-city tour.

After World War II, Americans were beginning to watch television. In 1952, *Death Valley Days* hit the airwaves, and for 11 years it was hosted by the "Old Ranger," Stanley Andrews. Then, in 1964, a young actor named Ronald Reagan took over the job. His stint only lasted a year, as he left to run for governor of California. The show, however, lasted until 1975, one of television's longest-running series. The Twenty Mule Team of Death Valley had become a true media star.

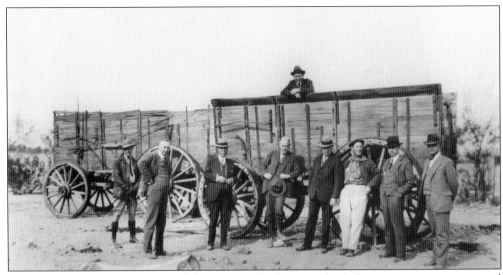

In 1927, Pacific Coast Borax opened the Furnace Creek Inn, and to help promote tourism it wanted Death Valley to become a national park. In the center of the photograph, Stephen Mather, the man who created the Twenty Mule Team brand, is holding his hat. He was now the first director of the National Park Service, which he and Horace Albright, a local boy from Bishop, California, created. Next to Mather (left) is Christian Zabriskie, president of US Borax Operations and for whom Zabriskie Point in Death Valley is named. Mather felt his own connections to the company would look like favoritism, so Death Valley would have to wait until the man in the wagon, Horace Albright, succeeded Mather as director. In February 1933, Albright lobbied Pres. Herbert Hoover, and Death Valley became a national monument.

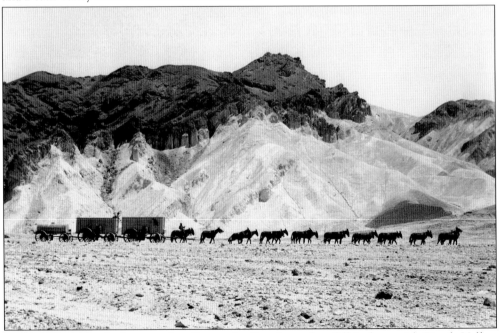

Burton Frasher took photographs all over the Southwest but fell in love with Death Valley. During the 1920s, he helped promote the Twenty Mule Team through postcards and the use of his photographs in books and articles. (Courtesy Frashers Fotos Collection.)

Frasher took this classic image of the
Twenty Mule Team reenactors in 1936,
paying their respects at the graves of
prospector Shorty Harris and Greenland
Ranch caretaker Jimmy Dayton.
(Courtesy Frashers Fotos Collection.)

Writer Ruth Woodman stands next to
the giant boiler at the Harmony Borax
Works. She wrote every episode of *Death
Valley Days* for radio and many for the
early episodes on television.

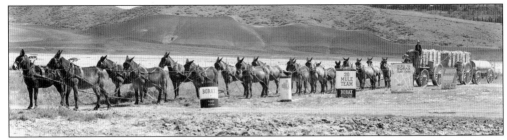

In new streamlined black and white packaging, 20 Mule Team Borax was released in 1935. A nationwide campaign promoted the new packaging.

In 1940, MGM released *20 Mule Team*, starring Wallace Beery. (Author's collection.)

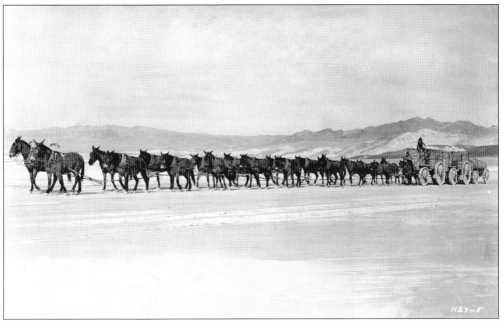

The company provided wagons and mules for the film. The mule in front of the wagon tongue (the pointer) is wearing a hat. Her name was Buttercup in the movie.

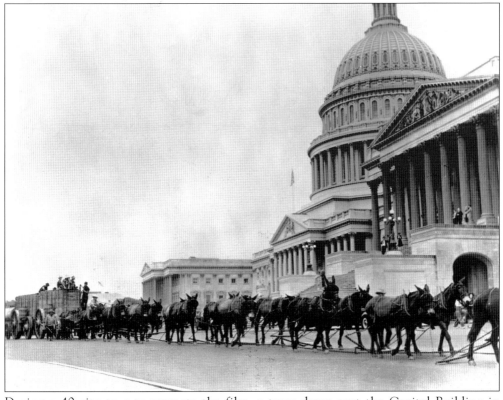

During a 40-city tour to promote the film, a team drove past the Capitol Building in Washington, DC.

In the center of the photograph is a mock-up of the Trylon and Perisphere, a thematic structure that embodied the concept of the 1939–1940 New York World's Fair. Amidst the throng is the Twenty Mule Team.

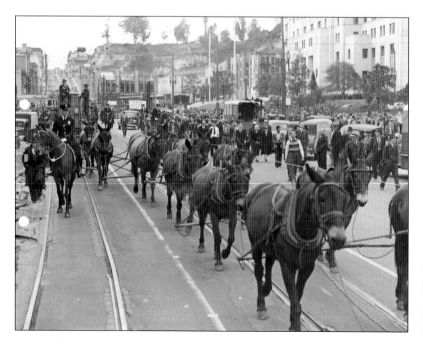

The movie tour of *20 Mule Team* concluded with a return to Los Angeles.

In 1952, *Death Valley Days* premiered on television. Its first host was Stanley Andrews. (Author's collection.)

In 1964, a young actor named Ronald Reagan hosted the show until he decided to pursue other aspirations.

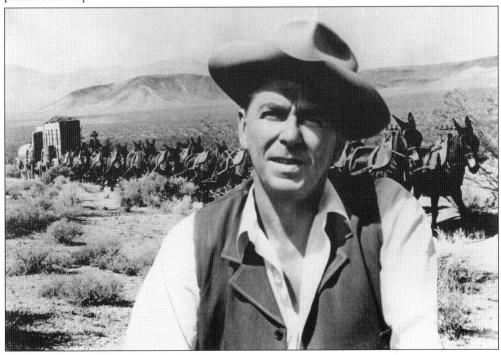

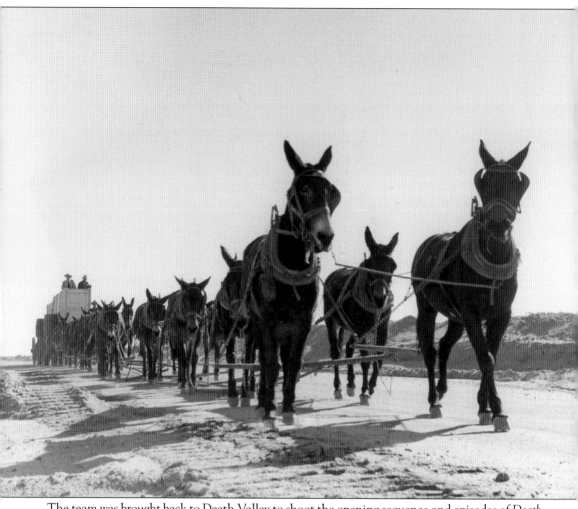

The team was brought back to Death Valley to shoot the opening sequence and episodes of *Death Valley Days*. This is a clear view of the jockey stick between the two lead mules that helps with steering. Riding in the wagon, wearing a tie, is the first host of the show, Stanley Andrews.

Ten

A LIVING LEGACY

The Twenty Mule Team continues to roll today. With the support of Rio Tinto Minerals (the descendant of Pacific Coast Borax Company) and the skill of a teamster from the foothills of the Sierra Nevada Mountains, the Twenty Mule Team still makes appearances. Research on the wagons is ongoing as to which ones are original to the Death Valley run. For current mule skinner Bobby Tanner, it all comes down to the spokes on the wheels. "The thing that distinguishes the wagons built for the Death Valley run is that their rear wheels have 18 spokes," says Tanner. Wagons with 16 spokes are most likely those built in Daggett by Seymour Alf. It is not so easy to say which wagons were used in Death Valley and which were not, as there were also smaller wagons used during Coleman's days at Harmony. One thing is certain, though: the only full-sized wagons that remain intact built closest to the specifications outlined in John Spears's book *Illustrated Sketches of Death Valley* are those on display at the Harmony Borax Works in Death Valley.

The Death Valley Conservancy, through its Borax Heritage Fund, along with other concerned parties, is seeking to create a set of working wagons exactly replicating the set at Harmony. The goal is to expose a new generation to the historic Twenty Mule Team by taking the wagons out on tour as well as documenting the construction and operation of the wagons and team. Recently, the author's company, Gold Creek Films, filmed for the first time the exact precision needed to turn a team.

When 20-mule teams were first in use, they were merely a means of transportation. They later became a brand and icon symbolic of the Wild West and synonymous with Death Valley. Today, Rio Tinto Minerals still mines borax at its facility in Boron, California, not far from the original 20-mule team route. Xanterra Corporation operates the historic Furnace Creek Inn and Ranch in Death Valley. The Dial Corporation (a Henkel Company) now owns and distributes the 20 Mule Team Borax laundry product. Though times have changed and technology has advanced, the Twenty Mule Team continues to represent the American spirit of teamwork, innovation, and the determination to overcome challenges.

In May 2011, on location for the annual Mule Days in Bishop, California, the team performed for the cameras. Here, mule skinner Bobby Tanner makes a turn with the two mules in front, the pointers, across the chain. Bobby is holding the jerk-line in his left hand and a line to the brake on the wagon in the other as the cameras from Gold Creek Films roll. The wagons seen here, dating at least from the borax operation of the 1890s, are on display at the Borax Visitor Center in Boron, California. (Courtesy Merilee Mitchell.)

The giant wagons that hauled through Death Valley can still be seen at the Harmony Borax Works. Here, in the desert sun stand the only original intact set of wagons that made the Death Valley run during the 1880s, later worked at the Borate mine, and then made several nationwide tours. They were simply the big-rig trucks of their day, taking borax to the railroad. Yet, through brilliant marketing that connected to the American character and spirit, they may have become, at one time, the most famous wagons in the world. Today, people are still drawn to the history, legends, and lore of the Twenty Mule Team of Death Valley. (Courtesy Merilee Mitchell.)

BIBLIOGRAPHY

Carter, Jimmy. *An Hour Before Daylight*, New York: Simon & Schuster, 2001.

Faye, Ted. *Of Myths and Men: Separating Fact from Fiction in the Twenty-Mule Team Story*. Proceedings Fifth Death Valley Conference on History and Prehistory. Bishop, CA: Community Printing and Publishing, 1999.

————. *The Twenty Mule Team of Death Valley*. Los Angeles: Gold Creek Films, 2000.

Glasscock, C.B. *Here's Death Valley*. Indianapolis: Bobbs-Merrill Company, 1940.

Gower, Harry P. *50 Years in Death Valley*. San Bernardino: Inland Printing, 1969.

Hildebrand, George H. *Borax Pioneer, Francis Marion Smith*. La Jolla: Howell-North Books, 1982.

Johnson, Benjamin. *The Grocer's Companion*. Boston: Benjamin Johnson, 1883.

Keeling, Patricia Jernigan. *Once Upon A Desert*. Barstow, CA: Mojave River Valley Museum: 1976.

Lemon, Dean. *The Harmony Borax Works of Death Valley, California*. Bishop, CA: Community Printing & Publishing, 2000.

Lingenfelter, Richard E. *Death Valley and the Amargosa, a Land of Illusion*. Berkeley and Los Angeles: University of California Press, 1986.

McCracken, Robert D. *Manse Ranch, Gateway to the Future*. Tonopah, NV: Nye County Press, 2009.

Paher, Stanley W. *Nevada Ghost Towns & Mining Camps*. Las Vegas, NV: Nevada Publications, 1984.

Scherer, James A. B. *The Lion of the Vigilantes, William T. Coleman and the Life of Old San Francisco*. Indianapolis: Bobbs-Merrill Co., 1939.

Serpico, Phil and Gustafson, Lee. *Coast Lines Depots, Valley Division*. Palmdale, CA: Omni Publications, 1996.

Settle, Glen A. *Bears-Borax and Gold*. Palmdale, CA: Kern-Antelope Historical Society, Inc., 1965.

Shamberger, Hugh A. *The Story of Candelaria and Its Neighbors*. Carson City: Nevada Historical Press, 1978.

Shankland, Robert. *Steve Mather of the National Parks*. New York: Alfred A. Knopf, 1951.

Spears, John R. *Illustrated Sketches of Death Valley and Other Borax Deserts of the Pacific Coast*. Chicago and New York: Rand McNally and Publishers, 1892.

Steele, James King. *Greater Oakland, 1911*. Oakland, CA: Pacific Publishing, 1911.

Travis, N.J. and E.J. Cocks. *The Tincal Trail, A History of Borax*. London, England: Harrap Limited, 1984.

Weight, Harold O. *Twenty Mule Team Days in Death Valley*. Twentynine Palms: Calico Press, 1955.

Wills, Irving, M.D. *The Jerk Line Team*. Los Angeles: Westerners Brand Book, 1961.

Woo, Cynthia. *In Harmony with History*. Los Angeles: Borax Pioneer, 1995.

Woodman, Ruth. *The Story of the Pacific Coast Borax Co*. Los Angeles: 1951.

FOR MORE INFORMATION:

20muleteams.com

Goldcreekfilms.com

Deathvalleyvideos.com

Dvconservancy.org

nps.gov/deva

Dvnha.org

Deathvalley49ers.org

DISCOVER THOUSANDS OF LOCAL HISTORY BOOKS
FEATURING MILLIONS OF VINTAGE IMAGES

Arcadia Publishing, the leading local history publisher in the United States, is committed to making history accessible and meaningful through publishing books that celebrate and preserve the heritage of America's people and places.

Find more books like this at
www.arcadiapublishing.com

Search for your hometown history, your old stomping grounds, and even your favorite sports team.